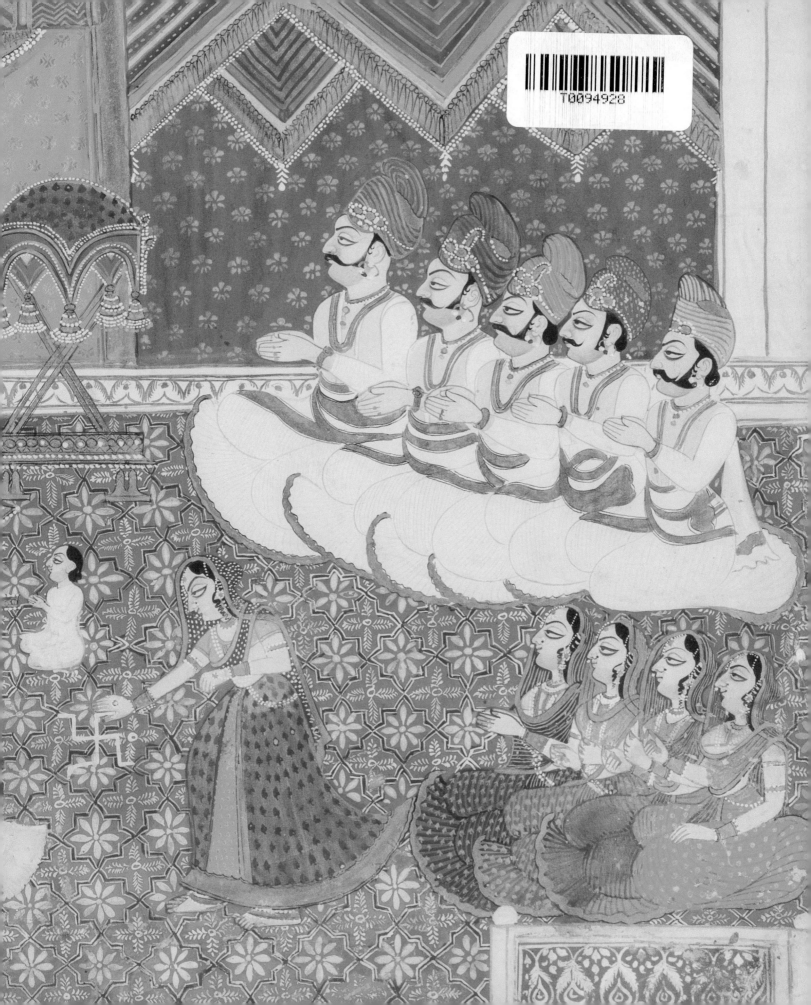

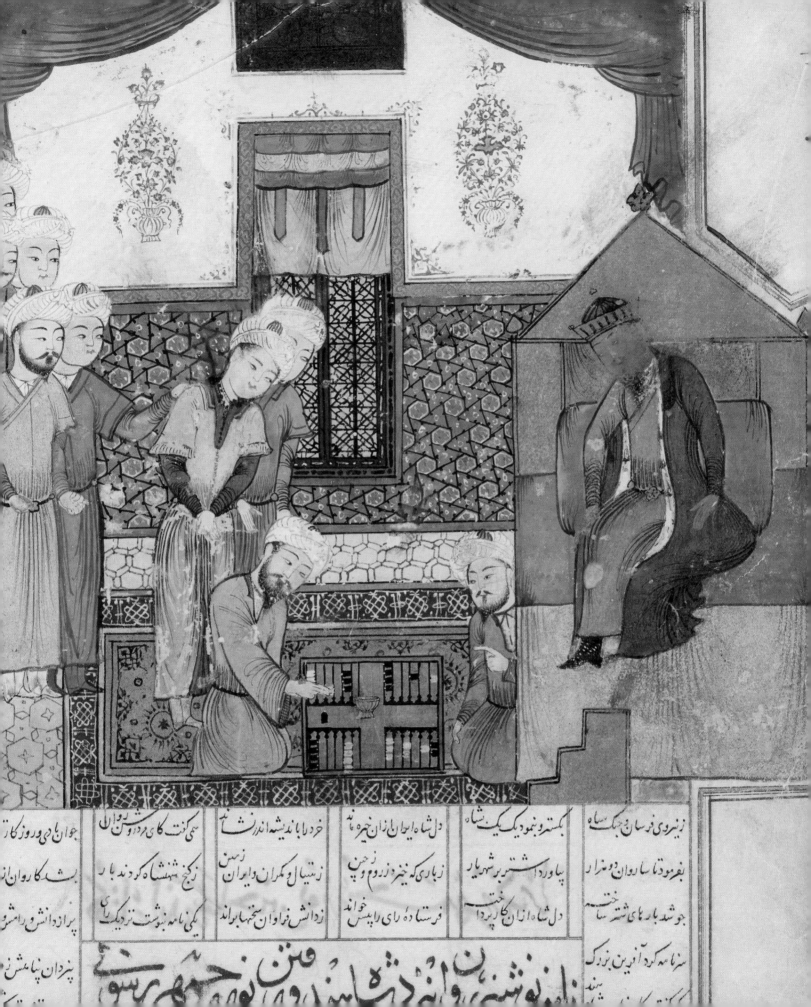

Art Unframed

at the San Diego Museum of Art

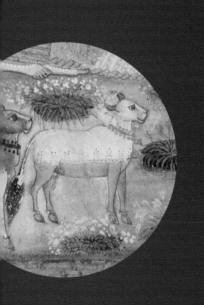

Peacocks and Palaces

Exploring the Art of India

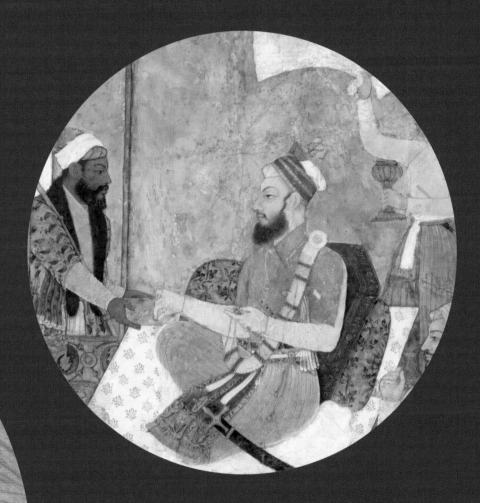

Lucy Holland

THE SAN DIEGO MUSEUM OF ART

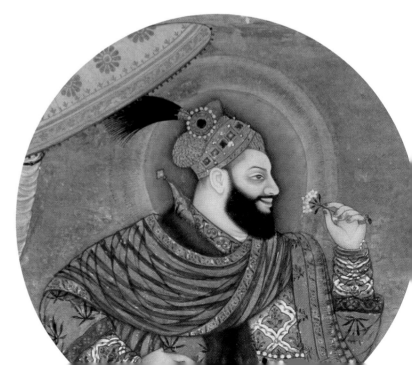

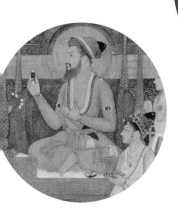

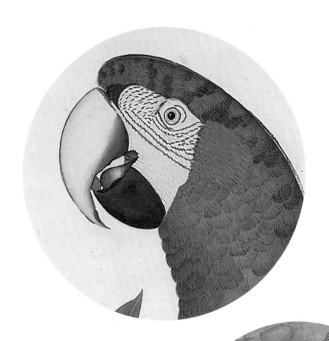

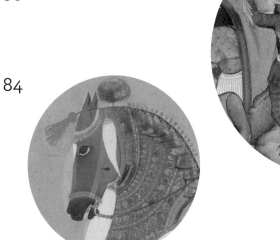

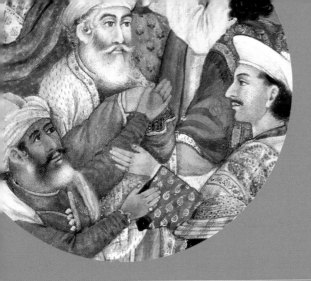

Foreword

At The San Diego Museum of Art, we value the importance of introducing young minds to the diversity and differences of other cultures, ideas, and arts. Among the many strengths of our holdings, the Museum has established one of the most prominent collections of Indian and South Asian art in the United States, thanks in large part to a bequest from Edwin Binney 3rd in 1990, and gifts from many other individuals. Recently, with the expansion of the Arts of South Asia gallery, the Museum has been able to showcase some of the finest objects from this impressive collection to provide our visitors a valuable firsthand experience with Indian art. Our Binney collection has traveled extensively and has been shared with international audiences from Mexico City to Quebec to Madrid and many other cities around the world. Now with this publication, *Peacocks and Palaces: Exploring the Art of India*, we offer a further opportunity for our young audiences to engage with artistic and cultural traditions that may be new to them, through the breadth and depth of the diverse collection of The San Diego Museum of Art.

Peacocks and Palaces is the second volume of the Art Unframed series, books intended for families to enjoy together as they learn about art from the Museum's collection. Within these pages, readers will learn about religions like Buddhism, Hinduism, Islam, and Sikhism, and works of art from stone sculptures to miniature paintings. In addition, this publication is also organized to educate and inspire the young audience to apply their own artistic creativity and to expand their intellectual horizons.

Much credit for the completion of *Peacocks and Palaces* goes to Anita Feldman, Deputy Director for Curatorial Affairs and Education, who led her educational team in extending the vision of this series, and to the author,

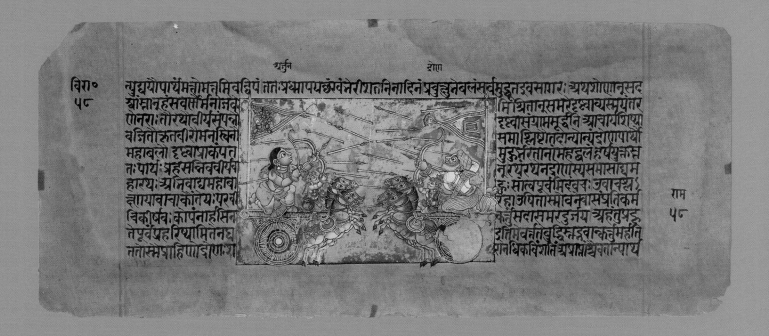

*The Battle between Arjuna
and His Guru, Dronacharya,
Southern India, Mysuru, 1670*

Lucy Holland, for her commitment to the Museum's goal of inspiring and educating the young and future generations. This publication would not have been possible without the generosity of the Museum's Arts Education Council, the Committee for the Arts of the Indian Subcontinent, and the Docent Council. We are also grateful for funding provided by the Indo-American Arts Society, as well as the generosity of many individual supporters: Behram and Rena Baxter; Jas Grewal and Suren Dutia; Ravinder and Cornelia Reddy; Ila Udani and Hasmukh Kamdar; and Deval Zaveri and Jimmy Tabb.

It is our belief that art is timeless and borderless, and we present this beautifully crafted book with the hope that young readers may embark on their own colorful and adventurous journey through the arts of India.

Roxana Velásquez

Maruja Baldwin Executive Director
The San Diego Museum of Art

Welcome to the Exciting World of Indian Art

Intended for readers and artists of all ages, *Peacocks and Palaces: Exploring the Art of India* is the second volume of the Art Unframed series from the collections of The San Diego Museum of Art. Spanning roughly two thousand years, this book continues a spirit of discovery by turning its focus to the art of India.

The Museum's encyclopedic South Asian painting collection of nearly 1,500 works surveys every major school of Indian painting from the twelfth through the nineteenth century. The workshop system in India led to the rise of different schools of painters who worked in closely related styles and were centered in royal courts. Here we look at the Mughal, Rajasthani, Pahari, Deccani, and South Indian schools of painting that flourished from the sixteenth through the nineteenth century, reflecting the historical and cultural legacies of this region's unique and dynamic identity.

The sixty-two works of art selected from the Museum's collection include objects from India and Pakistan, which along with Bangladesh, Sri Lanka, Bhutan, parts of Myanmar (Burma), and other regions in South Asia, are part of the area known as the Indian subcontinent. Themes explored through these works include many aspects of Indian history and culture, including religion, literature, architecture, music, and festivals. Throughout the book, interactive features provide opportunities for further investigation, while "Your Turn" features invite readers to try their own hands at creating art inspired by these themes. Removable elements, such as a magnifying glass for closely examining finely detailed miniature paintings,

truly bring the art to life. Terms in bold are defined in a glossary at the back of the book, where a timeline can also be found.

This interactive book was written and researched by Museum Educator Lucy Holland, with invaluable input from scholars of Asian art Dr. Diana Chou, Dr. Daniel Ehnbom, Dr. Sonya Rhie Quintanilla, and Dr. Marika Sardar, as well as advice from Jas Grewal and Dr. Ravinder Reddy, members of the Museum's Committee for the Arts of the Indian Subcontinent, and organizational and editorial guidance from a team of Museum staff including Gwen Gómez, Sarah Hilliard, and Cory Woodall. Many thanks are due to the diligence of these contributors in helping to make the collection of The San Diego Museum of Art more widely accessible to all audiences.

Anita Feldman

Deputy Director for Curatorial Affairs and Education
The San Diego Museum of Art

India has a long history of kingdoms that have risen and fallen over the centuries, each leaving a distinct legacy of art and culture. One of these early kingdoms was the great **Maurya Empire**, which covered much of India from 322 to 185 BC. After the Maurya Empire broke up, Northern India was not united until the end of the first century AD, when it was ruled by a series of kings under the **Kushan Empire**. Three centuries later, the **Gupta Empire** was established in the Ganges River valley. By AD 380, the Gupta Empire covered a vast region, including kingdoms to the east through Myanmar, north through Nepal, and the entire Indus Valley region to the northwest. Meanwhile, rule in Southern India was established by the Chola **dynasty** (family line of rulers). The **Chola Empire** prospered from the late 800s to the early 1200s and became known for its bronze sculptures (see page 24). Each empire would leave behind impressive works of art.

Your Turn

A Closer Look
Use the enclosed magnifying glass to locate details of works of art and get a closer look.

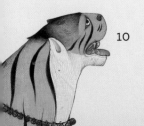

Great Guptas

The Gupta dynasty marked an important age in Indian art and culture. Wealthy Gupta kings were **patrons** of the arts (people who pay money for, or **commission**, the production of art) and the arts flourished under their rule. In addition to a focus on visual art, there were new developments in music, literature, **architecture**, philosophy, science, and mathematics. Beautiful cities dotted the empire, complete with universities and hospitals.

Musician and Destroyer

The Guptas followed the **Buddhist** and **Hindu** religions, so many religious themes are portrayed in art from this time. This sixth-century sculpture is of **Shiva**, the Hindu god of destruction and creation (see page 23). Sculptures like this one would have been located on the outside wall of a Hindu temple. He is holding a vina, a traditional Indian stringed musical instrument.

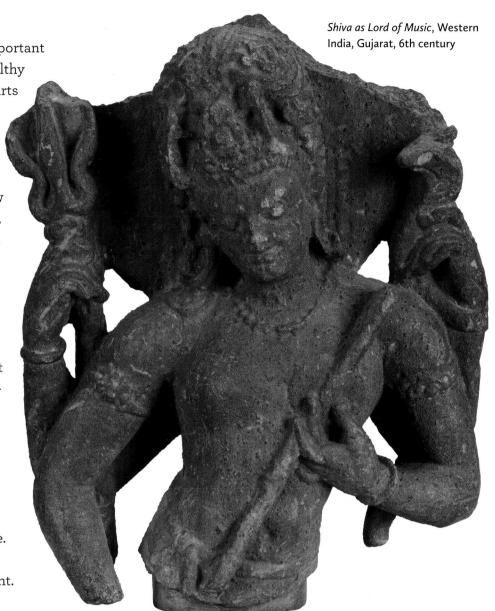

Shiva as Lord of Music, Western India, Gujarat, 6th century

Did You Know?

Astonishing new discoveries in astronomy were made during the Gupta period. An astronomer and mathematician named Aryabhata believed the Earth was round and described the orbits of planets around the sun in AD 499, centuries before European astronomer Copernicus would come up with a similar theory.

East Meets West

Sculptures from **Gandhara**, an ancient kingdom of Pakistan bordering Afghanistan, were made in a unique style. The empire of Alexander of Macedon (also known as Alexander the Great) extended to India in the fourth century BC, which laid a foundation for Mediterranean cultural features to take hold in art. Roman merchants brought Mediterranean imagery to the Arabian Sea, up the Indus River, and through the region of Gandhara to connect with the **Silk Road** (a network of trade routes crossing Asia and Europe) to China. Sculptures from Gandhara are made from the gray stone found in the region, known as schist, as well as terracotta (clay), and combine **Greco-Roman** features with Buddhist themes.

Princely Poses

This sculpture is of a **bodhisattva**, an enlightened being who is an important figure in the Buddhist religion. Bodhisattvas are usually dressed like princes to refer to the early life of Gautama **Buddha**, the founder of Buddhism, as a prince. Notice the bodhisattva's relaxed pose. This kind of stance is called **contrapposto**, when a figure's weight is shifted on one leg, and the body is gracefully balanced. This technique originated in ancient Greek art.

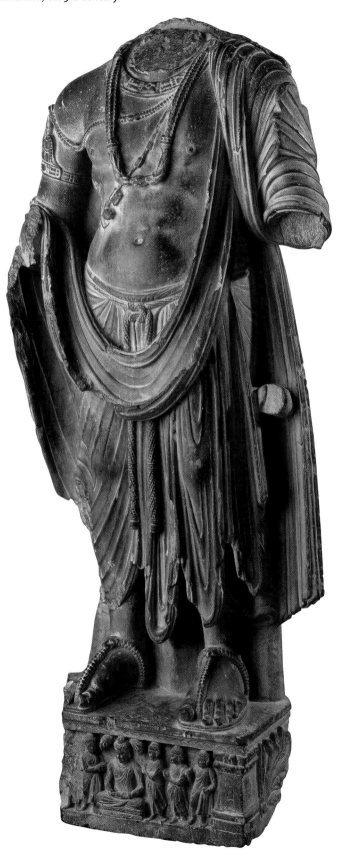

Standing Bodhisattva, Pakistan, ancient Gandhara, ca. 3rd century

The Buddha is Born

This panel from Gandhara portrays the story of **Siddhartha**, also known as Shakyamuni, who would later become the Buddha. In this **narrative** scene, Prince Siddhartha rode out of the palace one night in secret, when he realized that there was much suffering and unhappiness among his people and wanted to understand why. To look for answers, he left behind his life as a prince. Through traveling and **meditating**, he finally achieved spiritual **enlightenment** (total spiritual peace).

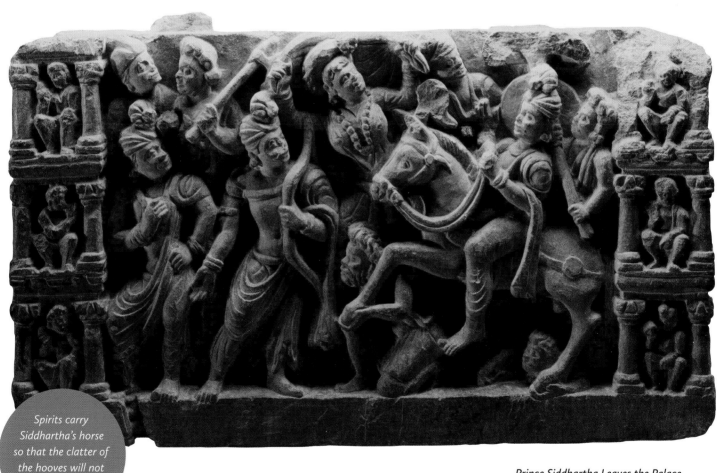

Spirits carry Siddhartha's horse so that the clatter of the hooves will not wake the palace guards.

Prince Siddhartha Leaves the Palace, Pakistan, ancient Gandhara, 2nd–3rd century

India is home to many of the world's religions, each of which plays an important role in India's diverse and rich cultural history. Four major religions began in India: **Hinduism**, **Buddhism**, **Jainism**, and **Sikhism**. The majority of India's population, about one billion people, are followers of Hinduism, the oldest continuous faith in the world. The next largest religion is **Islam**, whose followers, called **Muslims**, number about 170 million, and the third largest religion in India is **Christianity**, with twenty-eight million followers. There are more than twenty million followers of Sikhism, one of the world's youngest religions, in India. India is also home to a small population of Parsis, followers of **Zoroastrianism**, an ancient religion founded in Iran. Each religion is unique in its ideas of faith, ceremony, and celebration, and we can see religious themes depicted in Indian art through many centuries.

Sikh men wear a turban to wrap their hair, which is never cut in adherence to beliefs of the faith.

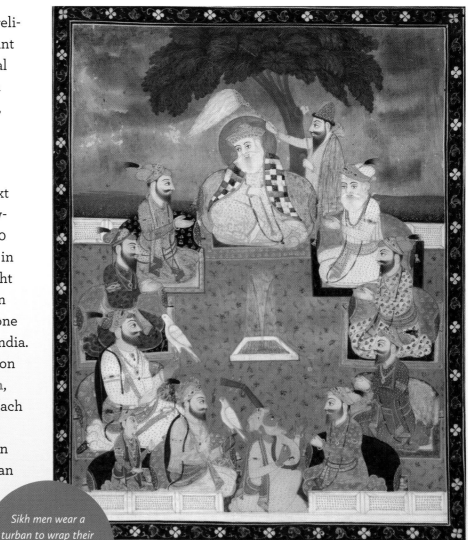

The Ten Sikh Gurus Seated in a Circle under a Tree, Pakistan, Lahore, ca. 1840

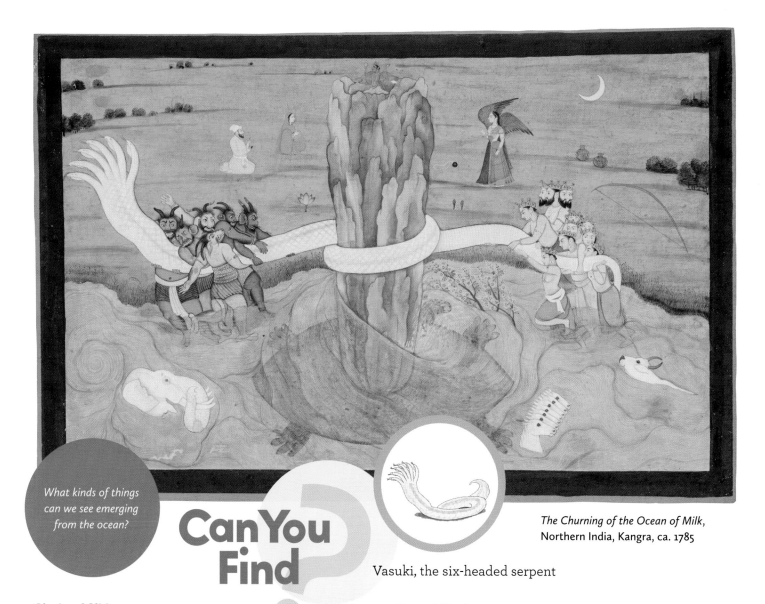

What kinds of things can we see emerging from the ocean?

Can You Find?

The Churning of the Ocean of Milk,
Northern India, Kangra, ca. 1785

Vasuki, the six-headed serpent

Circle of Sikhs

Sikhism is one of the world's youngest religions, founded in the fifteenth century in India. The faith adheres to beliefs taught by ten successive gurus and through the holy text called the Guru Granth Sahib. This painting celebrates the gurus, who sit in a circle beneath a tree. The first Sikh guru, Guru Nanak, is seated at the top with an attendant waving a fly whisk over him, while a musician sings praises among the other nine gurus in the circle. The child pictured at lower left is Guru Har Krishan, who became the youngest guru at the age of five, though he died just two years later.

Sacred Stories

Hinduism is founded on a series of ancient texts called the **Vedas**, which describe **myths** of creation and the lives of the gods and goddesses (see page 21). The story of the creation of the world is illustrated in *The Churning of the Ocean of Milk*. According to myth, the gods and demons worked together to churn an ocean of milk in order to generate *amrita*, a prized nectar of immortality. The Hindu God **Vishnu** sits on top of the holy mountain Mandara, which rests on the back of Kurma, an **incarnation** (form) of Vishnu as a giant tortoise. After a thousand long years of churning, miraculous things began to emerge from the ocean, including the nectar, which the gods then drank and became immortal.

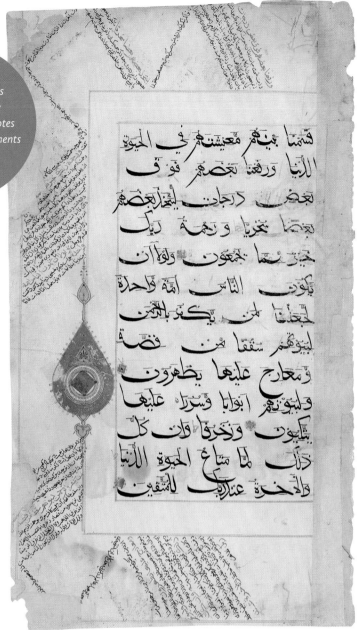

The diagonal lines of text along the page margins are notes explaining the statements in the Quran.

Holy Words

Islam was first introduced to India by Arab traders around the seventh century, and from the late twelfth century on, the religion became widespread through India. Floral and geometric **patterns** decorate passages of the **Quran**, the holy book of Islam, in this fourteenth-century **manuscript** (book) page. Large versions of the Quran, like this one, were displayed in **mosques**, the places where Muslims worship.

The Art of Writing

Calligraphy, the art of writing, became an important art form in India with the arrival of Islam. Over the centuries, many different styles of calligraphy developed. Calligraphy was written on cloth, **ceramics** (clay that has been hardened by heat), tile, or painted on walls until paper was introduced from China in the eighth century. **Calligraphers** used reed pens with nibs that were trimmed to different shapes.

Quran Page, Northern India, ca. 1400

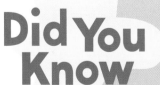

In the Islamic tradition, religious spaces and sacred books are not typically decorated with pictures of humans or animals. Instead, Islamic manuscripts are **illuminated** with decorative or **symbolic** images, such as this blue peacock-eye medallion.

Anatomy of a Buddha

This tenth-century sculpture shows the moment when Buddha found **enlightenment** sitting in **meditation** under a Bodhi tree, and he is gesturing to the earth to mark the moment. Here are some of Buddha's features that help us to identify him and indicate his religious achievements:

The Buddha in the Earth-Touching Gesture, Northeastern India, Bihar, 10th century

Did You Know?

Buddhism became one of the most widely practiced religions in East Asia. How did Buddhism spread from India? Starting around the second century BC, traders passed along the **Silk Road**. Many valuable commodities were transported over the Silk Road, as well as religion and ideas. **Monks** traveled east to China from India, bringing Buddhism with them, and later Chinese **pilgrims** (religious travelers) journeyed to India to study the religion.

Ushnisha – bump on top of Buddha's head; indicates spiritual knowledge

Stretched earlobes – refer to Buddha's former life as a prince when he wore heavy jewelry

Asana – pose; often sitting cross-legged in meditation, standing, or reclining

How does the Buddha's expression convey the emotion he must be experiencing in this moment?

Urna – symbolic third eye; center of knowledge

Lowered eyes – in meditation to practice quieting the mind and thoughts

Mudras – symbolic hand gestures; usually giving blessings, gifts of wisdom and reassurance, or focusing the mind

Lotus flower – symbol of purity

Sacred Places

Temples, mosques, and shrines are important places for worshippers of the many religions in India. Grand mosques offer sacred places for Muslims to attend prayer, while Hindu temples serve as places for daily *puja* (worship) and special rituals (religious ceremonies or actions). The central religious place of the Sikhs is the Golden Temple in Northern India, which serves as a symbol of the Sikh belief of equality among humans. Sacred sites are often richly decorated, with images of devotion adorning their interiors and exteriors. We can find many examples of devotional art and architecture, as well as important religious sites, in Indian art through the centuries.

Magnificent Mosque

The Pearl Mosque, built by the Mughal Emperor Shah Jahan (see page 37) inside Agra Fort, provided a peaceful place for Muslim worshippers to attend prayer. Made entirely of white marble, the mosque is perfectly symmetrical. From the top of a mosque, a *muezzin* (a person who announces the start of worship) calls Muslims to prayer five times a day, a practice called *salat*. Muslims pray in the direction of the holy city of Mecca, the birthplace of the prophet Muhammad.

Two Worshippers in the Moti Masjid (Pearl Mosque), Agra, India, ca. 1870

At least once in their lifetimes, Muslims make a **pilgrimage** (a holy trip) to Mecca.

Puja Places

Shrines (small areas that serve as places of worship) in Hindu temples would be adorned with altarpieces celebrating the gods, for whom devotees would leave offerings such as food, incense, flowers, or clothing. Here, a regal and bejeweled Vishnu, the powerful Hindu god (see page 21), stands next to his partner Shri Devi, also known as Lakshmi (see page 24). Below them on the front of the base is Vishnu's mount, the man-eagle Garuda. Decorating the outside parts of the sculpture are also a lotus flower and vyalas, griffin-like creatures that embody the creative energy of the divinities.

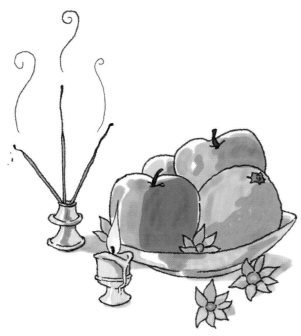

Altarpiece with Vishnu and Shri Devi,
Central India, Madhya Pradesh,
ca. 9th century

19

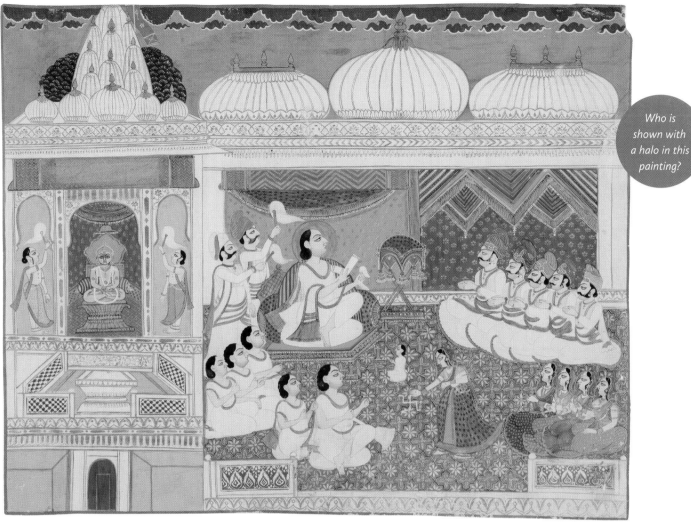

Who is shown with a halo in this painting?

A Scene in a Jain Temple, Northern India, Marwar, 1824

Won't Hurt a Fly

The monks dressed in white in this painting of a temple in Rajasthan are followers of Jainism, a religion practiced by over four million people in India. Jains, like Hindus and Buddhists, believe in nonviolence and compassion for all living beings, and they follow a very strict code for living. Here, a Jain monk, indicated by a golden halo, is teaching a row of rulers seated before him. Notice the white cloth he is holding, which is used to cover his mouth while speaking. This is so that he won't accidentally kill a bug should one fly into his mouth.

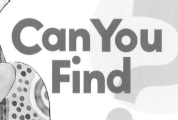

Can You Find

The life-size sculpture of a decorated *tirthankara* (Jain teacher)

Hindu Divinities

The Hindu religion includes numerous gods and goddesses, and many make appearances in Indian art. Each of the various branches of Hinduism believes in slightly different gods. There are generally three main divinities: Vishnu the Preserver, Shiva the Destroyer, and Devi the Great Goddess. There is also a supreme creator, Brahma, who many Hindus believe created all of the other gods. There are thought to be several different incarnations of each god, along with many demigods (gods that serve the supreme gods) and animal gods. These gods and goddesses, along with a colorful cast of demons, make popular subjects in Hindu art.

Blue, the color of the sky and water, is considered supremely beautiful in the Hindu tradition.

Did You Know?

Vishnu has ten incarnations, including a fish, a tortoise, a boar, and a man-lion.

The Blue-Skinned God

Who are the blue figures that appear in Indian paintings? Because of their blue complexions, we can recognize that they are not regular people. They are representations of gods from Hindu mythology. Vishnu, the god of preservation and protection, takes on ten different avatars (or incarnations), to defeat demons on earth. When Vishnu becomes Rama or Krishna, two earthly beings that appear to inspire followers, his skin appears blue. The color blue serves as a symbol that distinguishes him from the other figures.

Krishna Flutes under a Tree, Northern India, Kishangarh, ca. 1690

Krishna's flute caused the lightning storm in the background.

Seven monkeys

Can You Find?

A Cosmic Flute

Krishna, a human incarnation of Vishnu, is playing his magical flute in Vrindavana, the paradise where he lived with *gopis* (cowherders who were Krishna's closest followers) amidst beautiful plants, flowers, and exotic animals. According to a story from the *Bhagavata Purana* (see page 34), the mystical sound of Krishna's flute caused clouds to drop rain, and the river to stop flowing—even a boat has stopped before Krishna's feet. Notice the cows before him, which are a reminder of Krishna's origin as a cowherd, and the importance of the cow to Hindu culture (see page 71).

The Destroyer of Evil

The god Shiva is represented in many different forms in Hindu art. He is known as both a destroyer and creator; his destructive side symbolizes overcoming obstacles. With cobras surrounding his neck, Shiva appears with his wife **Parvati** and one of his sons, **Ganesh**, the elephant-headed god waving a fly whisk above him. A group of *sadhus* (holy men) have gathered to worship Shiva, along with two *ganas* (Shiva's troops), one white and one blue. Notice the river in the background. Water pours from Shiva's head to form India's most sacred river, the Ganges.

According to myth, Shiva rides Nandi (a bull), and Parvati rides a lion, who is licking his paws behind Shiva

The Elephant-Headed God

Ganesh is one of the most beloved Hindu gods. He is worshipped at the beginning of *puja* and start of any important endeavor, and his image is often located above temple doors. He is believed to bring abundance and help people to overcome obstacles. In his four arms, he holds a lotus flower, a bowl of sweets, and an axe, as leader of Shiva's army.

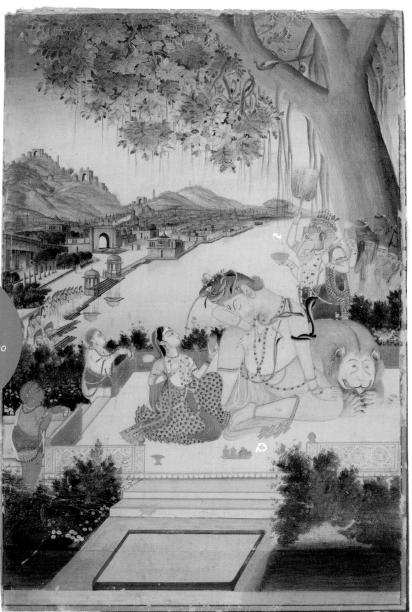

Lord Shiva Attended by Parvati, Northern India, Jaipur, ca. 1770

This sculpture is tiny, at just over two inches tall!

Ganesh, India, undated

Did You Know?

The mighty Ganges River has been deeply important for religious life and culture in India for centuries. Pilgrims visit the holy city of Varanasi (previously known as Benares) to wash themselves in its sacred waters as a form of ritual.

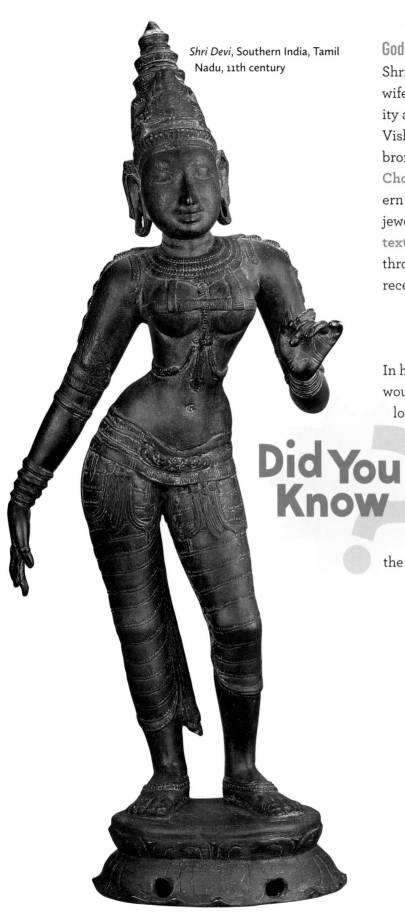

Shri Devi, Southern India, Tamil Nadu, 11th century

Goddess of Abundance

Shri Devi, also known as Lakshmi, is the wife of Vishnu. She symbolizes prosperity and good fortune, and accompanies Vishnu in his conquests. This exceptional bronze sculpture created during the **Chola dynasty** (see page 10) in Southern India would have been adorned with jewelry and flowers and dressed in fine **textiles** on festival days, and paraded through the city so that devotees could receive blessings from her presence.

Did You Know?

In her left hand, Shri Devi would have held a real or metal lotus flower, her symbol and Vishnu's favorite flower, and there would have been earrings in her ears. These are now missing from the sculpture.

Dreadful Demons

Can You Find?

The golden city of Dwarka from where Krishna flew

Krishna Approaches the Citadel of Naraka, Northern India, Bikaner, ca. 1710

Traditional Hindu stories are peppered with tales of demons upsetting the peace and balance in the world, with the gods continually keeping them in check. These *asuras*, or demons, were originally members of the same divine family of the gods. According to the ancient story of creation in Hindu sacred texts, the gods drank the prized nectar of immortality that came out of the ocean of milk (see page 15), leaving none for the mischief-causing demons. Representing evil forces and disorder in the world, demons continually are pursued and destroyed by the gods in Hindu stories.

Raiding the Demon Fortress

In this episode from the *Bhagavata Purana* (see page 34), Krishna battles an evil demon named Naraka who stole treasures from the gods and captured thousands of princesses. Krishna and his wife Satyabhama ride the man-eagle Garuda to destroy the demon's formidable fortress, which is surrounded by cliffs, swords, fire, winds, and a moat, and is guarded by the five-headed demon Mura. When they approach, Mura wakes from a deep sleep underwater and thunders a mighty roar. He is no match for Krishna, who blows away all of the fortifications with a single blast from his conch shell.

25

As a sequence in the great **epic** the *Ramayana* (see page 32), the demon Dhumraksha marches with his demon army to try to kill Rama and his brother **Lakshmana**. We can see these demons, armed with weapons and accompanied by fire-breathing dogs, are intent on their wicked mission. Dhumraksha, upon whom blood-red rain is falling and lightning strikes, does not succeed, however. He is defeated by **Hanuman**, the king of the monkeys, who aids and protects Rama in his quest.

Notice how the artist compresses the demons into a pile. It is hard to tell which parts belong to which demon.

Your Turn

Color a Demon

Imagine you are an artist painting a story that includes demons. What would your demons look like? On page 3 of the enclosed sketchbook, illustrate the demon using features, colors, and patterns of your choice.

The Demon Dhumraksha Leads his Army, Northern India, Kulu, ca. 1705

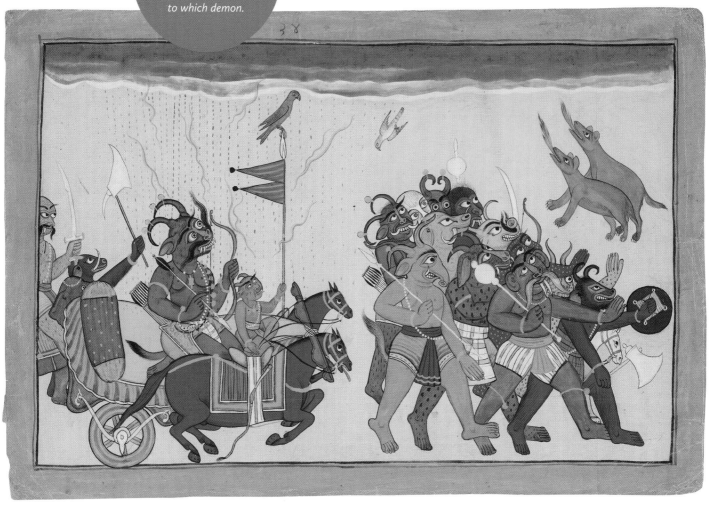

Demons in a Wild Landscape, Northern India, ca. 1600

A Day in the Life of a Demon

Busy, colorful demons attend to their daily business in this fanciful painting created for the Mughal emperor Akbar. The dangerous-looking demons, with their horns, spotted skins, and large ears, are in the middle of their regular routine in the mountains where they live. They are cooking elephant soup, bathing, fishing, feeding, and dancing. We can see the chief demon drinking *bhang*, a drink made from hemp, which was strained through a white cloth by the group of demons below him. Some demons are having fun—one blows his trumpet, while others dance festively.

Look closely—many demons wear strings of bells so that we can hear them approaching and be warned.

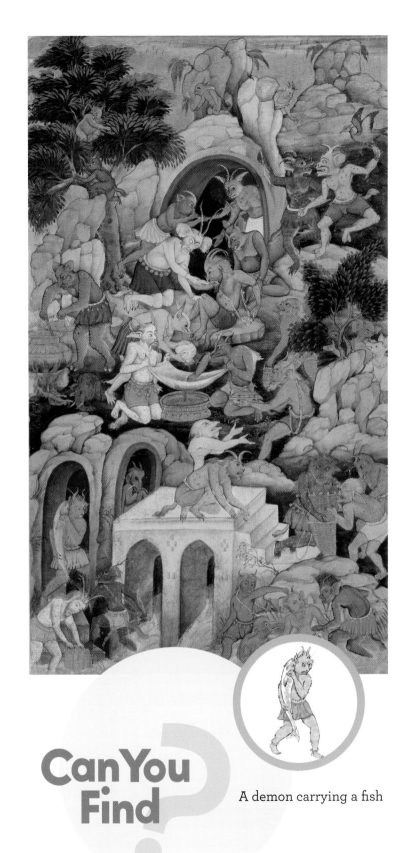

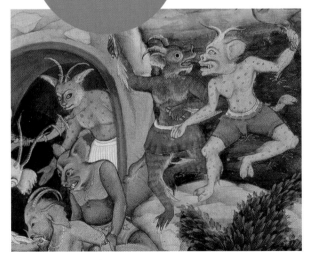

Can You Find?

A demon carrying a fish

Pigments and Paper
The Making of an Indian Painting

Painting in India is a tradition that differs from that in any other part of the world. Created to be included with manuscripts that would be held in one's hand, or as loose-leaf pages bound into albums, Indian miniature paintings were not meant to be framed or hung on walls. They varied from about the size of a postcard to up to two feet wide. Many were close in size to a standard sheet of paper, though some were even as small as a postage stamp! The earliest miniatures in India date back to the eleventh century, when paintings accompanied mainly religious texts. Later, royalty and other wealthy patrons began to commission artists to create illustrated books for pleasure, prestige, and posterity. Several schools, or distinct styles of art, developed in the different regions of India—including the Mughal, Rajasthani, Pahari, Deccani, and South Indian schools. Artists worked alongside other artists and calligraphers in workshops, many of which were run by families. The results were paintings that are highly detailed, required many steps to complete, and used some surprising materials.

Book It

Creating a book involved several steps. Workshop directors usually would assign the illustrations to artists, sometimes even writing the instructions on the page. Calligraphers wrote the text and left space for paintings. After the paintings were completed, the pages were sent to bookbinders who would finish them in leather covers for Muslim manuscripts, or wood or cloth covers for Hindu books.

Painters and Calligraphers Working. An illustration from the *Akhlaq-i-Nasiri* of Nasir ud-Din Tusi, ca. 1559–95. Prince Sadruddin Aga Khan Collection.

Preparing to Paint

Making an Indian miniature painting was a complicated process. First, an artist would create a drawing. Sometimes, the artist transferred the design to the painting surface with pounce, charcoal powder dusted through holes perforated in a drawing. The artist then would go over the charcoal lines using red and black ink, correcting any mistakes with white paint. To make gouache (a type of opaque, or non-transparent, watercolor), artists mixed pigments (colored powders ground from minerals, plants, or other materials) with water and gum arabic, a sticky medium made with sap from the acacia tree. Paint was mixed in seashells, and brushes were made from squirrel or kitten hairs. Artists would paint one layer at a time, ending with the fine details and applying gold last. Each layer was burnished (polished) to a sheen with a smoothed piece of agate (a type of stone). The heat and pressure of burnishing created a smooth, luminous surface.

Burnishing the paintings smooths out brushstrokes so that they become invisible.

To achieve super-fine details, artists would use a brush made from just one or two squirrel hairs!

Did You Know?

Artists in India painted on palm leaves until the mid-fifteenth century, when Muslim sultans (kings) introduced the art of painting on paper, a technique that had been first discovered in China.

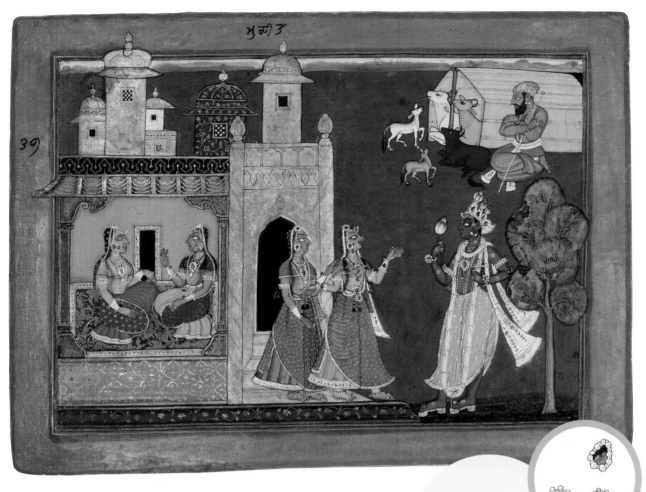

Kripal, *Delighted at the Prospect: The Nayika Mudita*, Northern India, Nurpur or Basohli, ca. 1665

Creative Colors

Pigments were made from a variety of insects, plants, and minerals found in India. Sometimes prized minerals were imported, such as lapis lazuli from Central Asia for ultramarine blue. Other times, pigments were obtained from some very unusual sources. To make Indian yellow, cows were fed mango leaves and their urine was dried to a powder. Preparing the pigments took a long time and was quite complicated, with secret "recipes" passed down by master painters. Artists also used gold leaf, gold that has been beaten into a very thin sheet, applied with glue and burnished to a gleam.

Can You Find

Jewels enhanced with beetle wings to look like emeralds

Colorful Critters

Insects were sometimes used by artists to produce unusual colors and effects. The kermes insect produced a crimson hue, while beetle wings were cut and glued to paintings to imitate the stunning glow of emeralds, such as in this painting from a Pahari workshop.

Traditional Color Sources for Indian Paintings

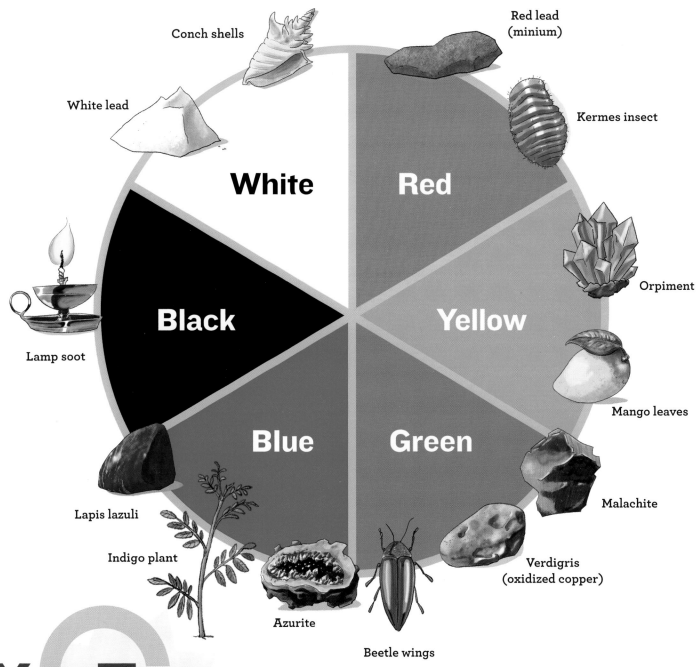

Conch shells
White lead
Lamp soot
Lapis lazuli
Indigo plant
Azurite
Beetle wings
Red lead (minium)
Kermes insect
Orpiment
Mango leaves
Malachite
Verdigris (oxidized copper)

White
Red
Yellow
Green
Blue
Black

Your Turn

Make your own pigments

Can you make your own colors using materials from nature? As an experiment, gather some colorful materials such as from plants, foods, or earth (blueberries, blades of grass, dirt, etc.) and see what kinds of colors you can get.

Many Indian paintings illustrate narratives—they were made to tell a story—and most were commissioned by royal patrons to be included in books. These tales, or epics, tell of the lives of kings, celebrated historic moments, or the adventures of gods and goddesses. Two great Sanskrit epics from ancient India, the *Mahabharata* and the *Ramayana*, contain some of the most popular stories from Hindu literature. The *Mahabharata* tells the tale of a long battle between two groups of cousins, the Kauravas and the Pandavas, and the *Ramayana* is an ancient story about Rama and his wife Sita. The *Bhagavata Purana*, Ancient Tales of the Lord Vishnu, and the *Gita Govinda*, Song of the Herdsman, also are illustrated often in Indian paintings. Meanwhile, tales from Persian literature have captured the imagination of Indian readers for centuries. The *Shahnama*, or Book of Kings, is one of the longest epics in the world, and tells the history of ancient kings of Iran (see page 57), while the *Tutinama*, Tales of a Parrot, relates colorful stories told by a parrot. Throughout all of these epics, themes of love, bravery, and devotion prevail.

Tales of Monkeys, Bears, and Vultures

In the *Ramayana*, which consists of five books written sometime between 400 BC and AD 100, Rama's wife Sita is captured by the evil demon Ravana. Rama and his brother Lakshmana set out on an epic quest to find her, taking them to the kingdom of the monkeys, where monkey and bear armies led by their leader, Hanuman, join in the search. In this moment, a giant bird named Sampati, King of the Vultures, suddenly appears and points the search party to Ravana's palace on the island of Lanka. After sharing this important news, Sampati's feathers grow back (they had previously burned because he had flown too close to the sun in saving his brother). The rescuers then devise a plan to reach Lanka and after a long battle, succeed in killing Ravana and his demons. Rama returns with Sita to his birthplace, Ayodhya, where he is crowned king.

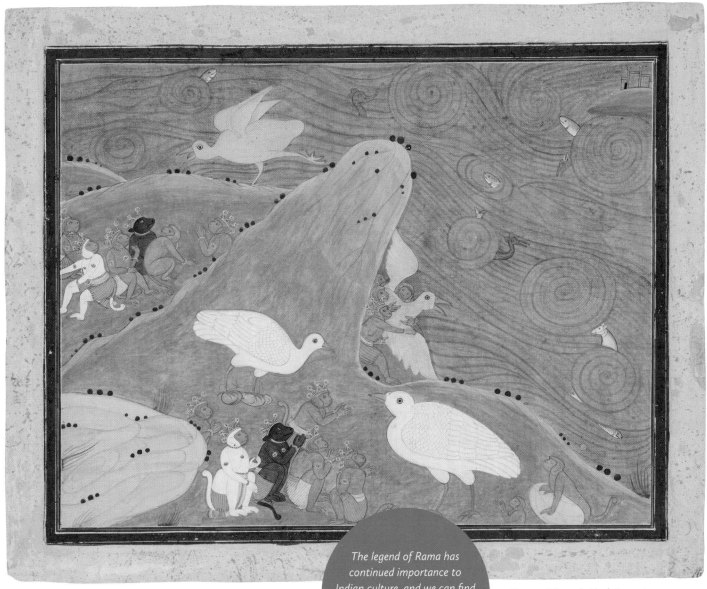

Sampati Reveals Sita's Location,
Northern India, Garhwal, ca. 1840

One Painting, Four Moments

Why do the same figures appear more than once in some paintings? Rather than capturing a single moment in time, Indian paintings sometimes show a sequence of events unfolding. This is known as **continuous narration**. At the upper left, a featherless Sampati arrives; in the center **foreground**, Sampati shares the news of Sita's whereabouts with the same monkeys and bears; in the middle center, Sampati takes off in flight after his feathers regrow.

The distant island
of Lanka

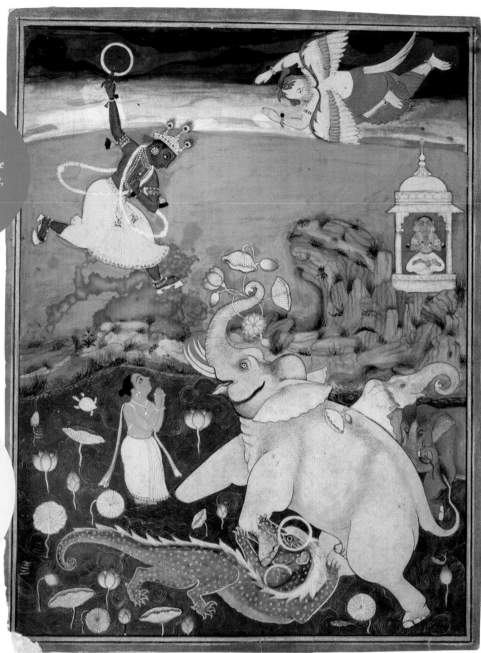

The Salvation of the King of the Elephants, Northern India, Bundi, ca. 1770

Can you see Vishnu's golden chakra twice—as he prepares to throw it, and as it hits the crocodile?

A turtle and a fish

Can You Find?

How the Elephant King Was Saved

Another popular epic, the *Bhagavata Purana*, is the source of some of the most beloved Hindu tales. Each of its twelve books gives accounts of Vishnu's ten **incarnations** (see page 21), which he takes on to defeat evil and restore balance to the earth. In this scene, Vishnu flies down to earth to save Gajendra, the King of the Elephants, who had been splashing in a lotus pond when he was seized by a crocodile.

He could not free himself from the creature's clutches, so he prayed for Vishnu (whose statue is in the painting) to rescue him. Vishnu appeared on his mount, Garuda, the flying man-eagle, and killed the beast with a toss of his *chakra* (disc weapon). We also see Gajendra as the human king Indradyumna, who he was before he was cursed to become an elephant.

The Jackal Who Pronounced Himself King, Northern India, ca. 1560–65

The Talking Parrot

A collection of stories similar to the famous *Arabian Nights*, the *Tutinama* features a talking parrot that tells a different story each night to a woman to keep her entertained while her husband is away. One evening, the parrot tells a tale of an ordinary jackal who one day accidentally falls into a vat of indigo dye. His new blue fur convinces the other animals that he is a god, and they declare jackal the king. He carefully keeps the larger animals at the edges of his court so that they can't hear his voice, which would give him away. He isn't able to fool them for long—the other animals soon discover that he is a fake as he barks and howls along with the other jackals, and his short reign as a god comes to an end.

What do the expressions and poses of each of the different animals reveal about how they might have felt about the Jackal King?

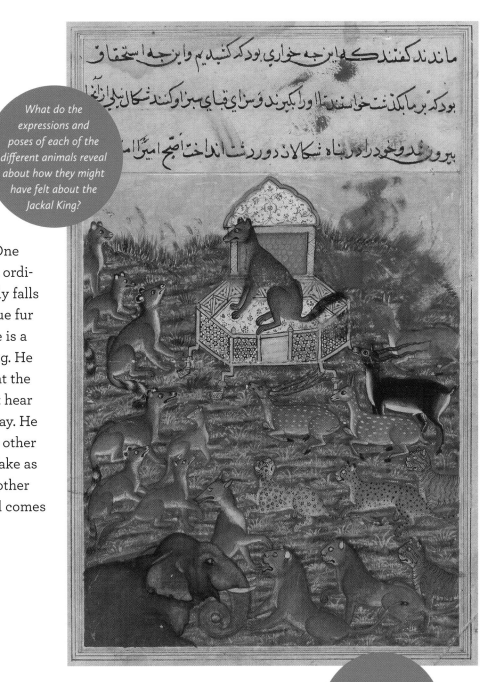

How many different types of animals can you identify?

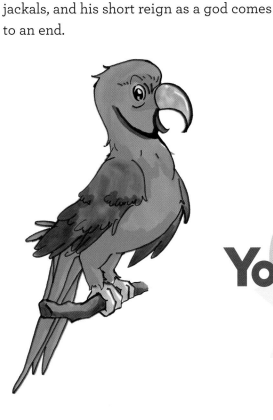

Your Turn

Illustrate a story

What is your favorite story? On page 5 of the enclosed sketchbook, write a story, either one you've read or one you've made up, and illustrate it. You can add words in **calligraphy** or fancy handwriting.

Mighty Mughals
Three Centuries of Art

Many subjects portrayed in art from India's past feature rulers and emperors, who were the patrons of much of the art created during their times. Paintings created for royal patrons often reveal their biographies (life histories) and stories from the empire. In these detailed works of art, we can also observe certain customs of a particular kingdom, and what would happen inside the royal residences. The Mughal Empire was one of the many great dynasties of India, replacing the Delhi Sultanate, the series of dynasties ruled by Muslim sultans. For three hundred years, from 1526 until 1858, Mughal rule covered most of the country, including parts of present-day Pakistan, Afghanistan, and Kashmir. The Mughals were responsible for the spread of many ideas through India, particularly art, architecture, and the religion of Islam. Babur, who ruled from 1526 to 1530 as the first Mughal emperor, was the first to bring Persian artists to the Indian court. His son and second Mughal emperor, Humayun, founded the first ateliers (art studios) that specialized in making beautifully illustrated manuscripts. The art of painting especially thrived under the third Mughal emperor, Akbar, who commissioned over one thousand paintings during his reign from 1556 to 1605. We can understand a lot about life in the royal courts by viewing works of art created for Mughal patrons.

Rulers often were painted with **halos** (discs that stand for power or spirituality). The halo emphasizes the ruler's importance or strength, and that the light of God is behind him. Find halos in other paintings in this book— these will lead you to an emperor, ruler, holy person, or god.

Did You Know?

"Mughal" is the Persian word for "Mongol." Babur was a descendant of the fourteenth-century conqueror Timur, and also of Genghis Khan, the legendary Mongol ruler of the thirteenth century.

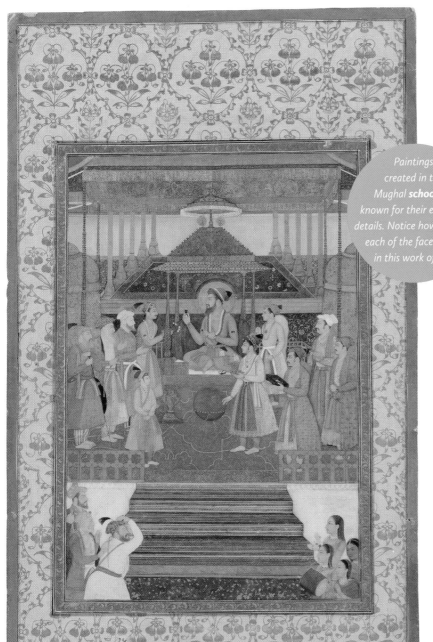

*Paintings created in the Mughal **school** are known for their exquisite details. Notice how realistic each of the faces looks in this work of art.*

A Fancy Birthday Party

The fifth and wealthiest Mughal emperor, Shah Jahan, who ruled between 1627 and 1658, was known for his love of art and architecture and for his passion for jewels and finery. The riches of the empire are on full display in paintings made during his reign. The occasion illustrated here is a celebration of the emperor's forty-sixth birthday, for which fancy decorations are hung. He is surrounded by his loyal nobles, sons, and other members of the court. The arrangement of figures in the painting reflects the strict rules for where people were to stand in the Mughal court—only the emperor could sit while everyone else stood at a specific distance from him in order of rank, or hierarchy.

Generous Gifts

The important celebration is marked by the exchange of expensive gifts. The emperor is giving a huge emerald topped with a pearl to his eldest son and heir, and gives other gifts such as the golden robes to the officials standing around him.

Fit for a King

The bejeweled throne on which Shah Jahan sits may be the fabled Peacock Throne, which was made from over a ton of gold and hundreds of rubies, emeralds, diamonds, and pearls. Costing twice the amount needed to build the Taj Mahal (see page 40), it is truly fit for a king.

Can You Find?

A woman playing a drum

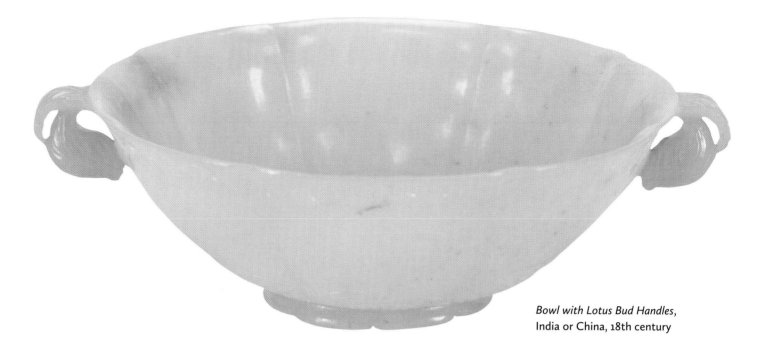

Bowl with Lotus Bud Handles,
India or China, 18th century

Art in Jade

The Mughal emperors treasured objects made of jade, the durable semiprecious stone that was imported from Central Asia. Craftsmen worked the hard material into extraordinary vessels (containers made to hold a liquid), with finely carved floral motifs—a difficult task to accomplish with jade. Bowls like this one later became popular in China, where emperors collected Mughal pieces and also copied their style so closely that scholars don't know whether this particular bowl was made in India or China.

Did You Know?

The artist's tiny signature appears at the bottom of one of the Chinese vases in the painting on the right. Chinese blue-and-white ceramics became popular through trade along the sea routes connecting India to other parts of Asia and Europe, which is how objects like these ended up in India.

38

Painting of Princes

This painting shows Shah Jahan's four sons and two grandsons. The highest in rank are at the back beneath the canopy, closest to the emperor, and the youngest are smaller and toward the front. Do the princes' poses seem relaxed or formal? Official royal portraits were usually very formal and posed, with faces depicted in profile, and the family's wealth and finest possessions on display for us to see. The chairs are made of gold and gems, and the canopy has the Mughals' imperial symbol of a sun and birds of paradise.

A Family Affair

The figure wearing yellow is Aurangzeb, Shah Jahan's fourth son, who became ruler of the Mughal dynasty in 1658 through a bitter family conflict. He murdered his older brother and overthrew his father, who spent the rest of his life locked in a tower overlooking the Taj Mahal. Aurangzeb would rule the empire for nearly fifty years, until 1707.

Bhawanidas, *A Gathering of Princes*, Northern India, ca. 1710

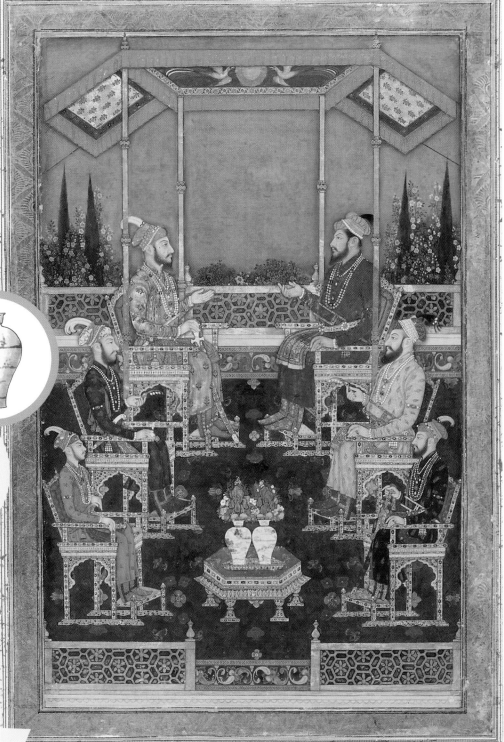

Who would be in your family portrait? Where would you and your other family members sit?

Two blue-and-white Chinese vases

Can You Find?

Your Turn

A Royal Court of Your Own

Imagine your own royal celebration. Who would be there? What kinds of gifts would you give to your friends and family? What would you receive from them? How would you decorate your party? On pages 6–7 of the enclosed sketchbook, draw your scene.

The Taj Mahal

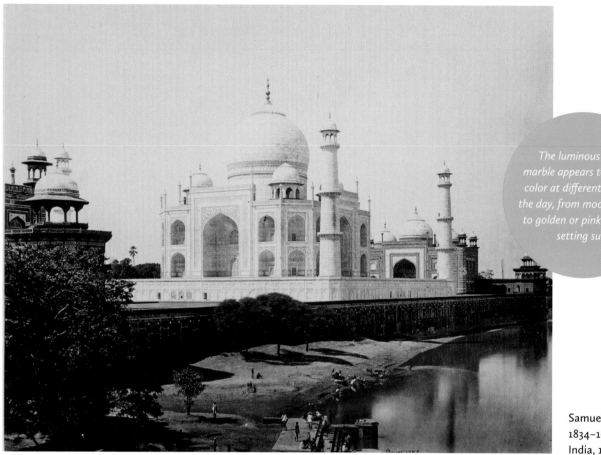

The luminous white marble appears to change color at different times of the day, from moonlit white to golden or pink with the setting sun.

Samuel Bourne (British, 1834–1912), *Taj from the River*, India, 1865

The Taj Mahal of Agra is one of India's most famous buildings, an example of Mughal architecture at its finest. It was constructed as a funerary monument for the beloved wife of emperor Shah Jahan, Mumtaz Mahal, whose name means "the Jewel of the Palace." Work began upon her death in 1631 and was completed in 1643. The Taj Mahal houses cenotaphs (monuments) for her and for Shah Jahan, whose tomb was added after his death in 1666. Built with stunning white marble, its design is perfectly symmetrical, identical from all four sides. It is exquisitely decorated, just like Shah Jahan's palaces, with floral patterns inlaid with precious stones, and calligraphy with passages from the Quran on the exterior. Four tall minarets (towers) stand at each corner of the structure and a mosque, a guesthouse, and other buildings are also located on the grounds. Carefully designed gardens, with cypress trees lining the paths and canals running through the center, were intended to represent the idea of paradise from the Quran, and were a feature particularly relished by Mughal emperors.

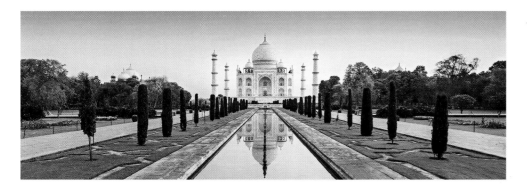

Taj Mahal today, Shutterstock

Building of a Masterpiece

The five-hundred-foot-tall Taj Mahal was an impressive feat of architecture. The expensive materials used to build it included many types of marble, which were brought from different regions in India and from as far away as China. Jewels inlaid in the marble were imported from all over the world. A massive amount of labor was used to construct it, and working elephants were used to transport heavy materials to the construction site.

Glittery Gems

The Mughals—especially Shah Jahan, who was interested in geology—greatly admired the Italian art of *pietra dura*, or inlaid precious stones, and adopted the technique for decorating their architecture. Colorful jewels and stones adorning the Taj Mahal in elaborate floral patterns were sourced from remote areas—lapis lazuli was brought from Afghanistan, emeralds from South America, amethyst from Persia. There is also turquoise, agate, coral, and more inlaid in detailed patterns in the marble.

Did You Know?

The Taj Mahal was recently declared one of the new seven wonders of the world. Over seven million people visit the monument each year from around the world, making it one of the world's most popular tourist destinations.

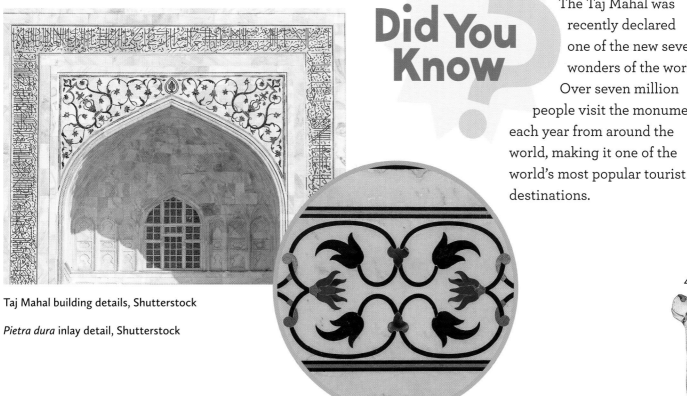

Taj Mahal building details, Shutterstock

Pietra dura inlay detail, Shutterstock

41

Royal Rajputs
Manuscripts Made for Sisodia Kings

Rulers of courts in all parts of India hired artists to produce beautifully illustrated books in their own studios. In the Rajasthan region of northern India, rulers known as **Rajputs** ("sons of kings") produced richly **illuminated manuscripts**. Though sometimes influenced by the ideas and art of the **Mughals**, many Rajputs were **Hindu** instead of **Muslim**. The Sisodia **Maharanas** ("great kings") of the Mewar court in south-central Rajasthan were an influential line of Rajputs who ruled for centuries. Works of art created in the **Rajasthani school** for Rajput kings often have distinct styles and color **palettes**. Paintings portrayed themes and stories drawing from a long history of Hindu literature, as well as images of the rulers of the time.

Relaxing in the Palace

This painting shows us the courtyard of a palace. Where is the king? Sangram Singh, the ruler of Mewar in the early sixteenth century, is sitting on a low throne at the upper right of his *darbar* (royal assembly). The king's family is present, with his daughter on his lap and his son at his side. There are also numerous court officials, musicians, and servants surrounding him. The king's favorite **yogi**, a white-haired man who served as a spiritual mentor, is sitting close to him. Paintings from Mewar were sometimes very formal, but this scene is a little less than most, and gives us a glimpse into the private life of the king and his family while they are relaxing at home.

Did You Know?

Paintings in the traditional Rajasthani style show people's faces in profile, which was seen as the noblest way to feature a face.

42

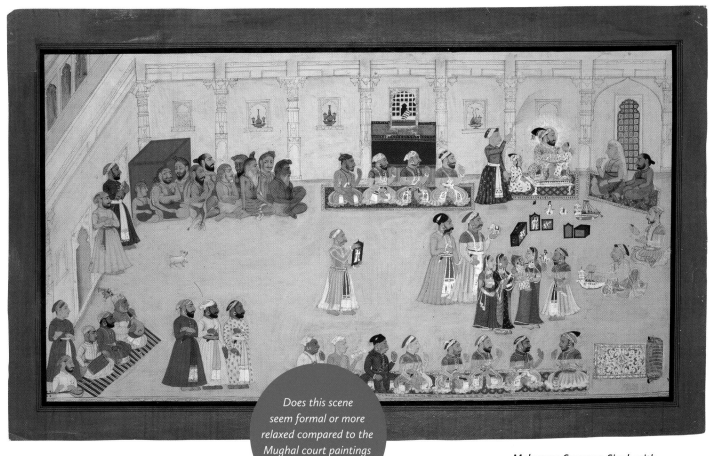

Does this scene seem formal or more relaxed compared to the Mughal court paintings (see pages 37 & 39)?

Maharana Sangram Singh with His Children and Courtiers, Northern India, Mewar, ca. 1715

Fun with Toys

In this delightful scene, a variety of new toys have arrived at court and are spread out for the children to play with. Find the king's youngest son, who is in his mother's arms. Courtiers (members of the royal court) are trying to entertain him, holding out toy elephants, boats, and other figurines. These kinds of toys were imported by Dutch merchants to the ports of western India, and probably had just been unwrapped.

What is (or was) your favorite toy?

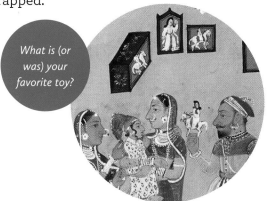

Can You Find

Two toy ships

43

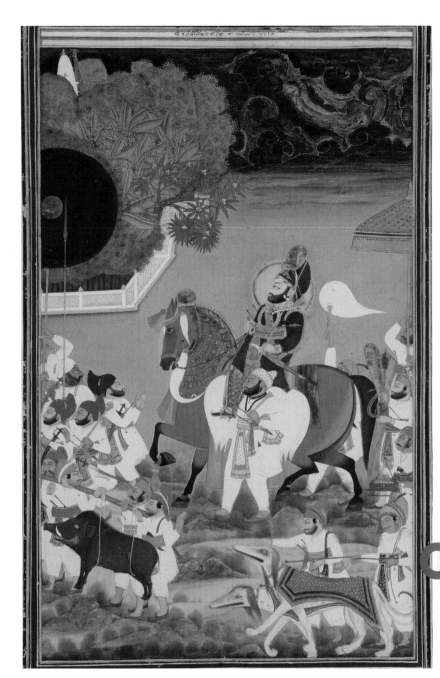

Chokha, *Maharana Bhim Singh Returns from the Hunt*, Northern India, Mewar, 1803

A Royal Hunt

The Mewar king Bhim Singh, who ruled during the late eighteenth and early nineteenth centuries, is returning from hunting in this painting. Hunting was a popular royal pastime, along with picnicking or relaxing in a garden or palace. The artist portrays the king in his finest royal green hunting clothing, decked out in expensive jewelry, accompanied by his courtiers and the numerous items they would bring along on the hunt.

Can You Find

A brazier (portable stove) with fire embers

Did You Know

The pair of hunting dogs in the **foreground** may be Salukis, or **Persian** greyhounds, one of the earliest breeds of dogs found in Asia. Salukis were commonly used in the region for hunting and known for their keen eyesight.

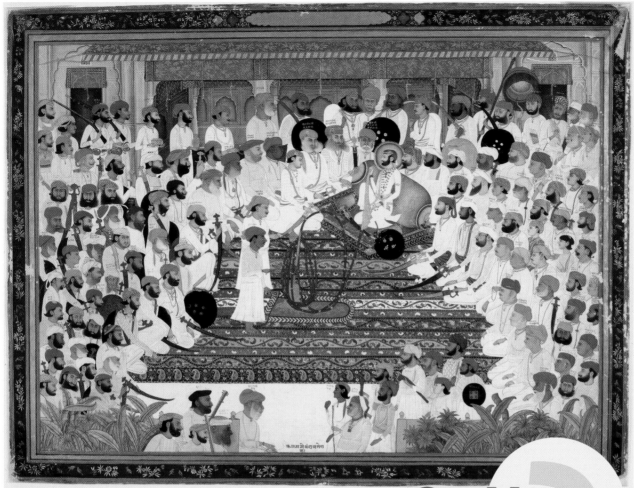

Gobind, *The Darbar of Raja Bakhtawar Singh of Alwar*,
Northern India, Alwar, ca. 1810

Faces in the Crowd

The Rajput ruler Maharao Raja Bakhtawar
Singh, who ruled the kingdom of Alwar
in Rajasthan at the turn of the nineteenth
century, is surrounded by more than 120
members of his *darbar* in this painting.
Notice how the artist painted each figure
in the crowd with individual features,
clothing, turbans, and hairstyles. Even
the men's beard styles are unique. There
are captions written on each person so
that we can identify their roles in court,
which include everything from command-
ers, advisers, and accountants to carpet
spreaders and staff bearers.

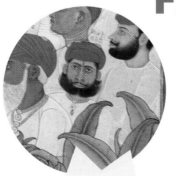

Can You Find?

1. Twelve people looking
 directly out at us
2. Three green turbans
3. Seven blue turbans
4. Two men holding rifles
5. One man holding a
 bow and arrow

Did You Know?

The artist himself, named Gobind,
appears in this painting, facing out toward
the viewer at the lower right hand side.

Sultans of the Deccan, the south central part of India, and other southern regions, developed unique styles of painting. Most of Central and Southern India remained independently ruled for centuries, where distinct styles and art-making methods developed. Traditional Deccani school art (art created in the Deccan region in a particular style) features an array of distinctive colors, often vibrant, with fanciful backgrounds. Rulers of the Deccan often were portrayed in relaxed scenes—enjoying private moments, sitting with court members, or strolling through gardens sniffing flowers. The Deccan was very diverse, with populations of Turks, Arabs, Persians, and Africans, whom we sometimes see in paintings of the period. Art of the South Indian school (art produced in the southern region of India) also flourished with unique techniques in painting as well as sculpture, metalwork, and architecture.

The King of Taste

Look at how the sultan of Golconda, a court in the Deccan region, appears in this portrait. Sultan Abu'l Hasan, who ruled in the late seventeenth century, was a famous poet and had a flair for enjoying the good things in life—flowers, elegant clothing, delicious food. We can see that he is wearing multiple layers of fine clothing, furs, and jewels. His *jama* (overdress), which he wears over his *paijama* (pants), is made of expensive, embroidered fabric (fabric that has decorative patterns of thread sewn into it). An attendant is protecting him from the sun with a shield, which suggests the sultan's royal status. The colors are typical of works created in the style of the Deccani school. What do you notice about the colors in this painting?

Green-colored halos like the one that illuminates this sultan were usually painted with verdigris, a color made from oxidized copper (see page 31). Green is often a holy color for Muslims. Unfortunately, verdigris had a tendency to corrode (or deteriorate) paper over time, unless it was mixed with saffron, the yellow-hued spice.

Portrait of Sultan Abu'l Hasan of Golconda, Standing, Central India, Golconda, ca. 1675

This sultan was known as Tana Shah, the King of Taste. Why do you think he had this title?

Can You Find?

A ruby ring

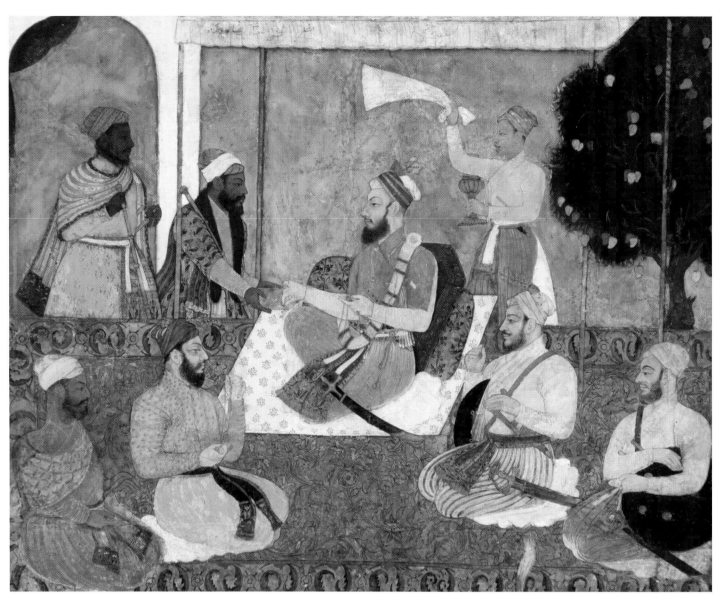

Muhammad Adil Shah Selects a Jewel,
Central India, Bijapur, ca. 1650

A Missing Jewel

Here Muhammad Adil Shah, a
sultan who ruled the Deccan court
of Bijapur in the seventeenth
century, is picking a jewel from
a tray offered by his favorite
adviser. Could he be missing
a jewel on the necklace he is
holding in his hand? Though there
is Mughal influence in the style of this
work, the scene is less formal. This sultan
seems welcoming, sitting on a carpet on
the floor along with his court officials.

*Halo today, gone
tomorrow: The sultan has
no halo, with which many other
rulers are shown (see page 36).
How else does he appear more
approachable than other sultans
or kings in other paintings?*

Did You Know?

An attendant is waving a cloth whisk to ward off flies. This was a common practice in Indian courts, though often the more formal fly whisk made from a yak tail, known as a *chauri*, would be used.

Kings of the South

In Southern India, the Wodeyar (or Wadiyar) dynasty ruled the kingdom of Mysore (now known as Mysuru) for nearly 500 years, remaining mostly independent from outside rule for centuries. This lithograph (a type of print) features Krishnaraja Wodeyar III, who ruled from 1799 to 1868. He is worshipping at a shrine within the palace that features the Hindu goddess Durga (known as Chamundeshvari in Southern India), who rides a lion. Other Hindu divinities are arranged and labeled in three rows below her. Priests worship her with offerings, and a small boy, possibly the king's son, holds a text inscribed with the name of the goddess.

Krishnaraja Wodeyar III Worships the Goddess Chamundeshvari, Southern India, Mysuru, 1859

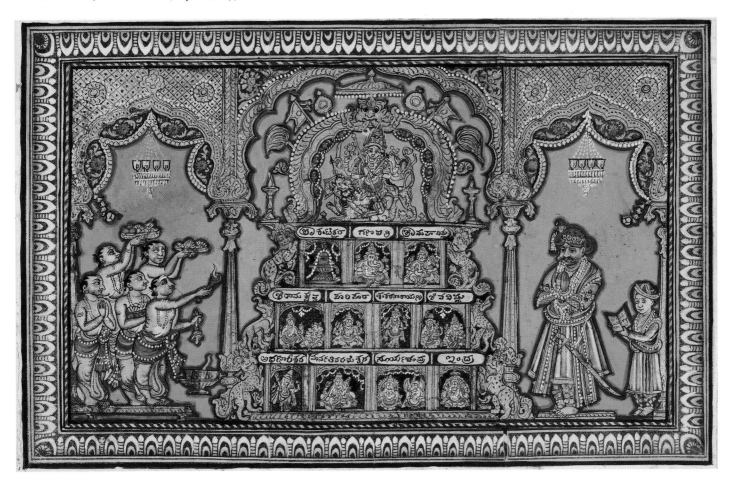

Many scenes of royal life in India during times of imperial rule unfold in palaces and inside forts. Fortified cities were built by rulers as centers for the empire and for protection from invasion, with huge walls surrounding them as strategies for defense. Each fort contained numerous richly decorated palaces, where the royal families lived. The Mughal rulers held their capital cities inside forts, first at Delhi, then the Red Fort at Agra. Massive sandstone walls enclosed the forts, which included palaces, mosques, elaborate gardens, and lavish decorations. Other powerful rulers such as the Rajputs of northern India would also construct grand palaces within forts. We can learn about what life in the palace was like by looking at images of them in works of art.

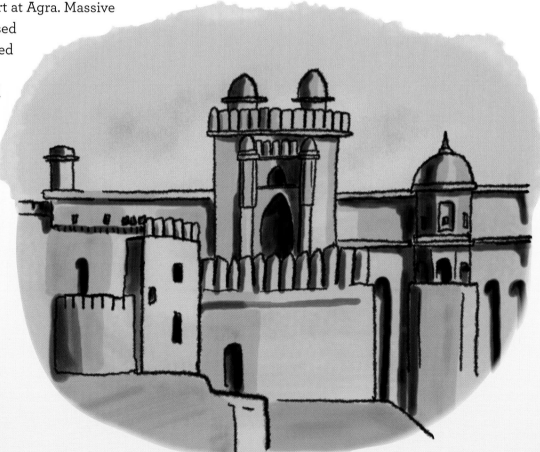

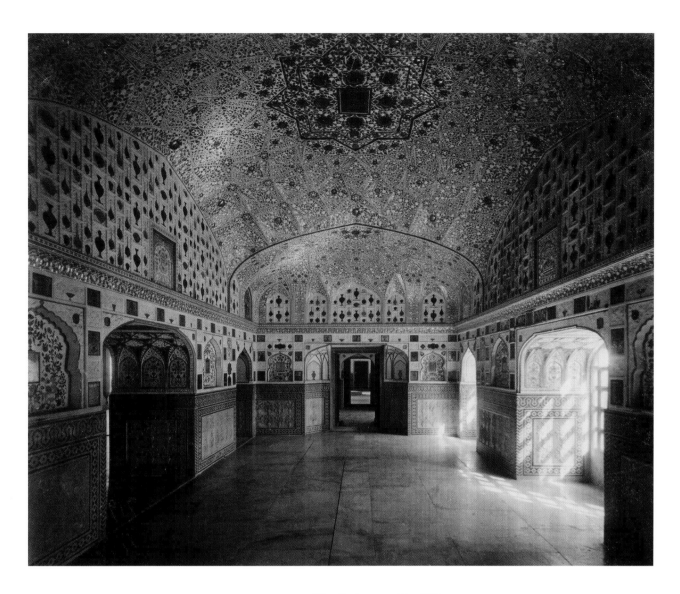

Shish Mahal, Amber Palace, Jeypore, ca. 1890

Did You Know?

Amber Fort was abandoned in the eighteenth century. Maharaja Jai Singh II, whose family had lived at the hilltop fortress for generations, moved to Jaipur, the city he built in the plains below (which was named after him).

The Palace on the Hill

Amber (or Amer) Fort in Rajasthan, which has stood since the eleventh century, is one of the spectacular historic sites of northern India. The fortified palace was home to the Rajput kings, their families, and numerous members of the court. Because it was built at the top of a hill, it would have been very hard to attack the fort and any invaders could be spotted from a distance. The palace within contained beautiful, spacious halls, including a Shish Mahal, a lavish, glittering room decorated in thousands of mirrors.

Princess and Companions on a Moonlit Terrace, Northern India, Lucknow, ca. 1760

A Day in the Life of a Princess

Scenes of life unfolding inside palace settings became quite popular in royal courts. In this fanciful scene, a princess is enjoying a moonlit evening on the palace terrace while dancers entertain her. However, the artist must have used his imagination—the women's quarters of a palace would have been off-limits to artists.

Notice the moon in the painting. How many different reflections of it do you see in the palace ponds?

Pierced Screen, Northern India, early 17th century or later

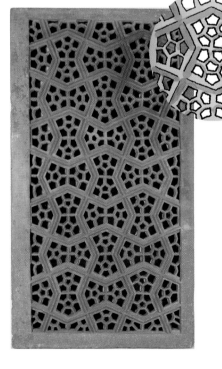

Privacy, Please

Decorative screens, called *jalis,* would have adorned palace windows, mosques, or other important buildings, providing a natural privacy screen while keeping the air flowing. The screens were chiseled from stone in intricate geometric or floral patterns.

Can You Find

Four birds

Plan Your Palace

Imagine you lived in a palace. What would it be like? Decorate the palace included here with windows, towers, or other decorations, and then assemble it. You can add the garden plan from the activity in chapter 9, or create your own additions.

Fun and Games

A Royal Pool Party

Palaces would often have swimming pools located within the royal courtyards. The Maharana of Mewar, Jagat Singh II, who ruled in the mid-eighteenth century, is enjoying a hot day in the palace pool. It looks like the king, with his halo and an attendant following him around with a fly whisk, might be playing a game of tag with the man to his right. Not to appear too informal, though, the king is still wearing his fine jewelry, even while swimming!

Can You Find?

A man making flatbread

Jai Ram, *Maharana Jagat Singh II Frolics in a Palace Pool*, Northern India, Mewar, ca. 1746–50

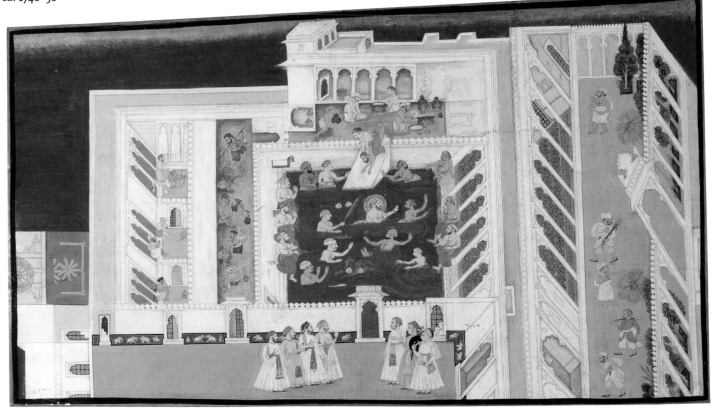

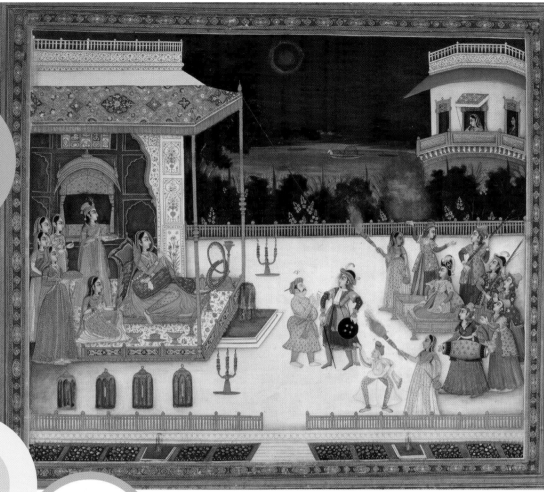

Mir Miran, *Queen Udham Bai Entertained*, Northern India, 1742

Since ancient times, a huqqa (*pipe*) has been a **symbol** of luxury associated with royalty in India.

Can You Find?

Two women watching the performance from afar

View from Above

Notice the perspective in the painting on the left. We can see both the inside and outside of the palace at the same time, allowing us to appreciate the architectural details that would not otherwise be visible. The men in the foreground are standing on a roof, above the scene unfolding below. They appear larger than the figures below, showing scale and distance. From our bird's-eye view, we can also see numerous servants and other officials scurrying about behind the scenes, preparing food and cooking over fires.

A Royal Performance

Entertainment at the royal court was a grand affair. A host of musicians, performers, singers, and actors would put on displays for the delight of the royal family. This lively group entertains Udham Bai, wife of the Mughal emperor Muhammad Shah (see page 78). They appear to be enacting a play about Portuguese military leaders, though the story of this performance is now lost to us.

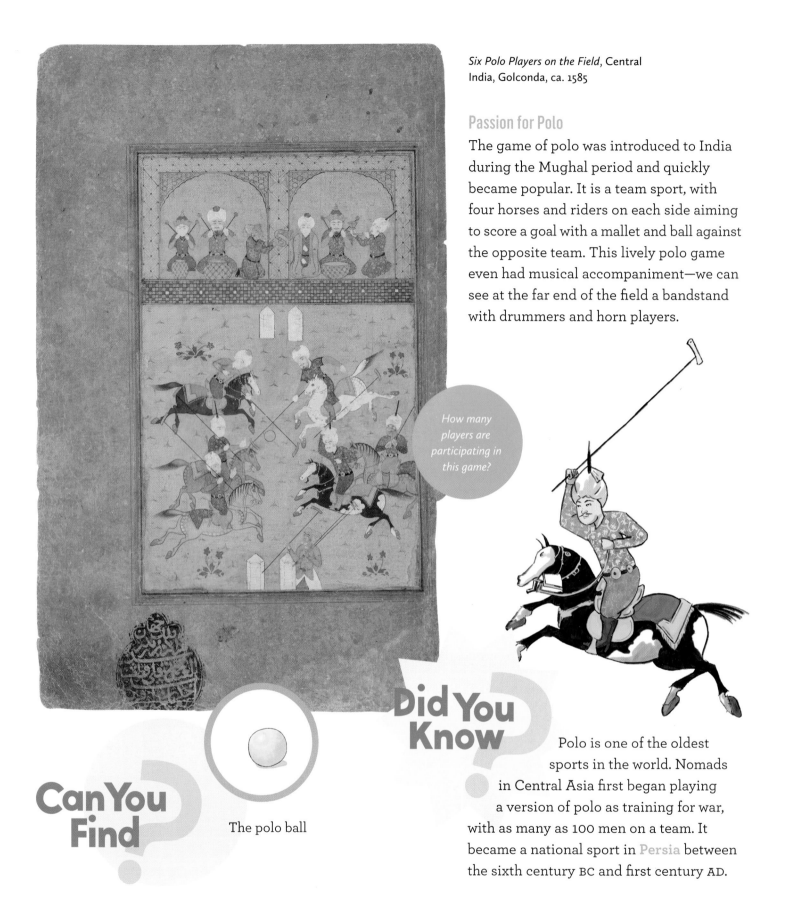

Six Polo Players on the Field, Central India, Golconda, ca. 1585

Passion for Polo

The game of polo was introduced to India during the Mughal period and quickly became popular. It is a team sport, with four horses and riders on each side aiming to score a goal with a mallet and ball against the opposite team. This lively polo game even had musical accompaniment—we can see at the far end of the field a bandstand with drummers and horn players.

How many players are participating in this game?

Did You Know?

Polo is one of the oldest sports in the world. Nomads in Central Asia first began playing a version of polo as training for war, with as many as 100 men on a team. It became a national sport in Persia between the sixth century BC and first century AD.

Can You Find?

The polo ball

Buzurjmihr Invents the Game of Backgammon and Shows How It Is Played, Northern India, ca. 1500

Game of Kings

The Mughals were fond of their games. In this painting of a story from the Persian epic the *Shahnama* (see page 32), a courtier named Buzurjmihr explains the rules of backgammon to Anushirvan, the king of Iran. Buzurjmihr invented backgammon in response to a challenge. The king of India had sent a chess set to Anushirvan, challenging the Iranians to figure out how it was played. The Iranians were able to do so, and came up with backgammon as a counter-challenge.

Timeless Tilework

Notice the beautiful tilework that we can observe inside this royal palace. How many different types of patterns and colors can you see? Persian tilework is famous for its remarkable geometry and intricate patterns. Building from basic shapes such as a square, circle, or star, shapes grow and intertwine into complicated designs. This sacred geometry is often thought to express divine unity and order.

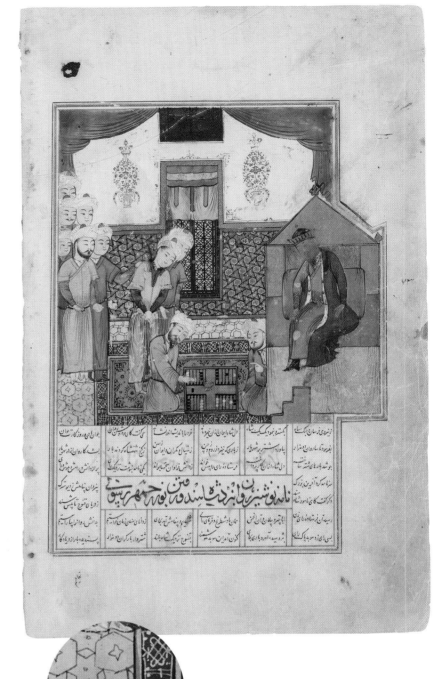

Lavish Landscapes
The Art of the Indian Garden

Rulers would build impressive royal gardens to delight their families and officials, and grand palaces had impressive gardens with canals flowing through them, scented flowers, and carefully selected plants. The tradition of the garden in India goes back to Islamic ideas of the "paradise garden," a heavenly oasis full of plants, water, and beauty. Water is especially important to gardens and we rarely see one without the characteristic stream running through its center. Mughal gardens would be divided symmetrically into four parts and lined with water. Even the plants chosen for gardens would be symbols, or stand for something. For example, flowering plums stand for life while cypress trees symbolize death. Gardens often included fruit trees, which Mughal emperors were very fond of, as well as almond trees, grapes, and all kinds of flowers, from irises to roses. Gardens served as a backdrop for scenes of courtly life unfolding, or as lavish landscapes in Hindu literature.

Did You Know?

Mughal gardens are laid out in four parts, called *charbagh*. *Char* means "four" and *bagh* means "garden" in Persian.

Mughal emperors loved gardens so much that they sometimes even ordered the walls of palaces to be painted with floral **motifs**, which turned the palace into virtual flower gardens with plant-like columns, water channels, and flower beds painted on the walls.

Abu'l Hasan, *Emperor Jahangir with Holy Men in a Garden*, Northern India, ca. 1615 (album page 18th century)

An Evening in the Garden

In this painting, the fourth Mughal emperor, Jahangir, who ruled between 1605 and 1627, sits in a garden that could be Shalimar Gardens in Kashmir. Jahangir loved nature and built many beautiful gardens, including this one in 1620. There is a religious ceremony being held, and food is being cooked in a large cauldron. Sufi holy men (followers of **Sufism**, a branch of Islam) sing enchanting songs and delight the emperor with mystical dances. By including this scene in his illustrated **biography**, the emperor wanted to show his close ties to the holy men and connection to religion.

What time of day is it here?

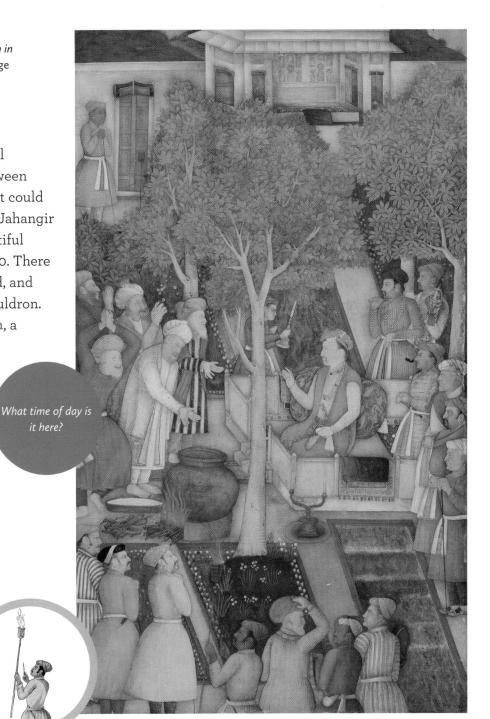

CanYou Find ?

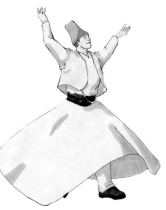

A man holding a torch

Dervish Dances

Dervishes perform an enchanting dance that is meant to inspire feelings of connection to God as part of the Sufi religion. During part of the dance, whirling dervishes spin counterclockwise many times, which symbolizes their spiritual journey.

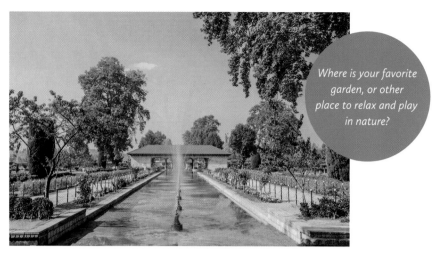

Shalimar Gardens today, Shutterstock

Where is your favorite garden, or other place to relax and play in nature?

Roses Are Red

This scene based on Hindu **mythology** unfolds against a magnificent garden backdrop. The Hindu god **Krishna** (see page 22) and his companion **Radha** are reaching for lotus flowers on a lake. Notice the geometric garden arrangement and the water element running through the center. Hundreds of tiny red roses are laid out in each of the garden plots.

Radha and Krishna Pick Lotuses from a Lake, Northern India, Kishangarh, ca. 1755

Mountains and Water

Jahangir's Shalimar Gardens in Kashmir, set against the snow-capped backdrop of the Himalayas, were terraced into three levels, with water running through the center from a nearby stream. A few stunning marble buildings served as places to sit quietly and enjoy the surroundings. The gardens were so beautiful that Jahangir's successor, Shah Jahan, constructed a similar one in Lahore, Pakistan.

This painting is based on a poem from a book of seven hundred love poems by Bihari Lal written in the seventh century.

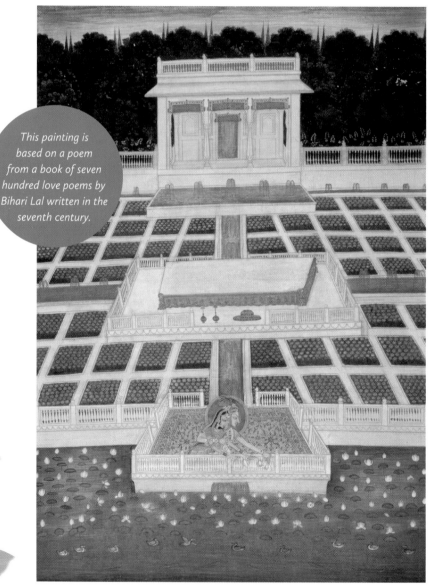

Did You Know?

Royal gardens had fountains that sprayed water impressively into the air without the use of electric-powered pumps. Water from nearby streams was stored in cisterns (large water containers), so that as it flowed out, gravity generated enough pressure to power the fountains.

Your Turn

Design a Royal Garden

What would your royal garden look like? Would you include water fountains and any specific types of plants or trees? Use the stickers at the back of the book to decorate your garden.

India's history is scattered with periods of European influence and rule. For centuries, Arab merchants brought Indian goods into Europe. Eventually, traders from Holland, France, and Britain ventured to India themselves to supply silks, tea, spices, and other luxurious goods to growing markets in Europe. The British set up the **British East India Company** around 1600 for trading purposes and began to **colonize** India in the mid-1700s. As the **Mughal Empire** began to decline and then fell in the mid-eighteenth century, leaving the country without a unifying empire, the British seized control. By the nineteenth century, they had control of Delhi and a century of British rule, called the **British Raj** (Raj means "rule" in the **Hindi** language), officially began, lasting from 1858 to 1947. The Mughal emperors were allowed to remain in their palaces, where they kept their courtly rituals, but they had no power. With British rule came heavy taxes, new political systems, construction of the railroads, as well as influences in art.

The Mughals Meet the British

Akbar Shah II, the next-to-last Mughal emperor who ruled from 1806 to 1837, is meeting the British Resident (government official). The Mughal Empire was quickly falling to British control at the time this was painted, though royal studios continued to create paintings celebrating the emperor.

Did You Know?

The emperor is being carried in a palanquin (a type of chair or bed mounted on four poles), a luxurious mode of transportation for royalty used for centuries in India.

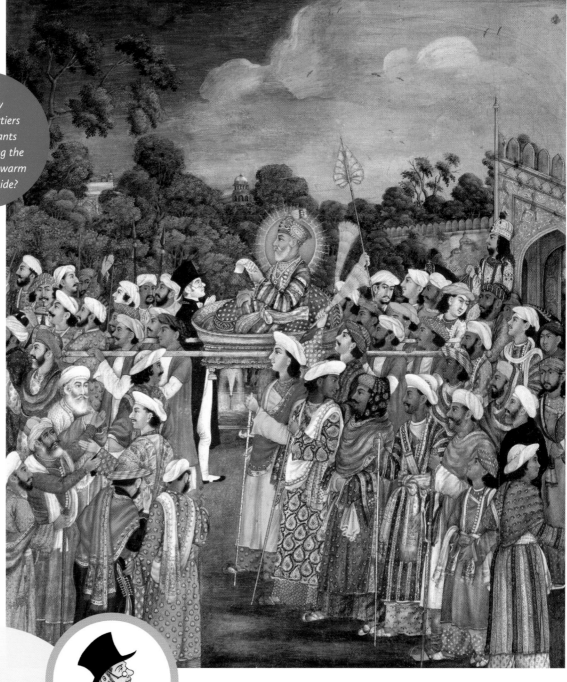

Akbar Shah II Receives the British Resident, Northern India, ca. 1810

Notice the richly dressed courtiers and attendants accompanying the emperor. Is it warm or cold outside?

Can You Find

The British Resident

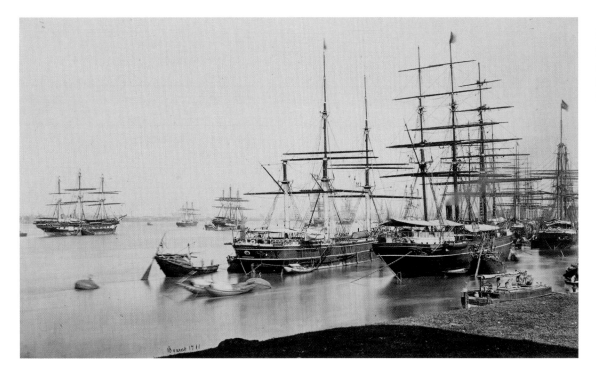

Samuel Bourne (British, 1834–1912), *Shipping Boats in the Hooghly River from Fort Point*, India, 1867

From India to London

This photograph, taken in 1867 by British photographer Samuel Bourne, who traveled through India and documented its architecture and landscapes, captures the trade between India and Europe during the British Raj. Tall shipping boats line the Hooghly River near Kolkata (formerly Calcutta) in the state of West Bengal in northeastern India. Kolkata was originally founded as the capital of the East India Company's trading center, and became the capital of the British Raj. With its prime location on the Hooghly River, a branch of the Ganges, the city provided direct access to shipping routes through the Bay of Bengal to Europe.

Through the Lens

Samuel Bourne spent several years documenting the major sites in India just a few decades after the invention of photography in 1839. Early photography was difficult and involved many steps. Bourne had to drag a lot of heavy equipment around with him with the help of up to forty-two porters, carrying all of the needed chemicals to develop the photographs on-site. Undoubtedly, he would have shared this photograph and others, along with tales of faraway places when he returned to Britain in 1870.

Calcutta was the anglicized (English) name given to the Bengali city. In 2001, the government of West Bengal officially changed the name of the city to Kolkata.

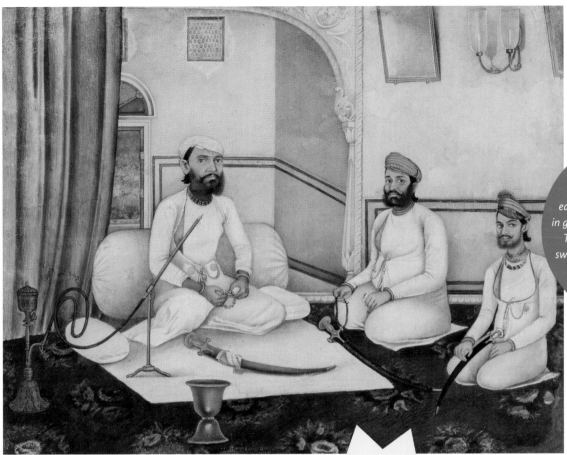

Laxmi Narayan, *Thakur Sahab Samadr Karanji with Kabraji Mukandra Karanji Sahab and Bhao Raj Cha*, Northern India, Jaipur, ca. 1875

The names and ranks of each of the nobles are written in gold on the wall next to them. The main figure holding the sword is a **thakur**, *the title of a lord or master.*

The Company Style

Indian painters, through the influence of European art, began to paint in a new style. **Company school** paintings, as they were called, were created for European **patrons** through the eighteenth and nineteenth centuries. This style combined new techniques in **perspective**, shading, and **modeling** with traditional Indian styles. It wouldn't be until the twentieth century that Indian artists like Nandalal Bose (see page 85) would revive distinctly Indian styles of art.

Did You Know?

Objects from Europe made their way to India during this time, such as European glass lamps, stained glass windows, and Victorian carpets that were new decorations of the Jaipur palace.

Your Turn

Be the Decorator

How would you decorate the interior of your home or palace? Using the outline on pages 8–9 of the enclosed sketchbook, draw carpets, wall decorations, light fixtures, and any art that might hang on the walls.

11

Into Nature
Observing the Natural World

Since the sixteenth century, artists in India have been inspired to paint many subjects from nature. Artists looked to the natural world around them, documenting flora and fauna (plants and animals). Plants and animals often appear in Indian art, through illustrations of folklore, as a backdrop for scenes unfolding, or as subjects in themselves. Flowers were especially important, not just within gardens, but also for their use in garlands and adornments in religious ceremonies and festivals. Many paintings of plants were done in small format, to be included in **manuscripts** or albums. Carefully designed floral borders frequently adorn paintings, with both real and imagined species creating intricate **patterns**. **Botanical illustration**, made from studying nature, also was becoming a popular **genre** (subject type in art) through Europe and beyond.

Flora and Fauna

Mughal emperors were fascinated by nature, and often had their court artists document plants, flowers, and animals in very **realistic** studies. Jahangir (see page 59) was especially interested in the natural world and his court artists illustrated many new or unusual specimens. The pheasant, which was brought to the emperor as a gift, is painted in exquisite detail here, along with a lady's slipper orchid, an exotic species of flower.

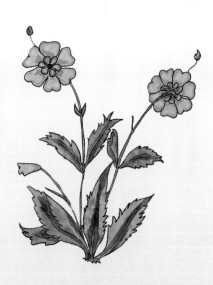

A Himalayan Cheer Pheasant, Northern India, ca. 1620 (border ca. 1635)

Shaikh Zayn al-Din, *A Green-winged Macaw*, Eastern India, Kolkata, ca. 1780

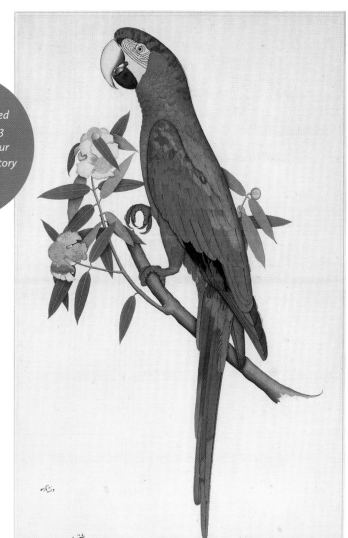

Lady Impey returned to England in 1783 with more than four hundred natural history illustrations.

Can You Find?

A red orchid

The ornate floral border was added to the painting several years later.

A Private Zoo

Created in the **Company** style (see page 65), this painting of a green-winged macaw has been studied very closely. Even the tree branch on which it rests is a study of an actual species. The macaw is not native to India, so how did it get there? It probably belonged to Lady Mary Impey, wife of the British Chief Justice of Bengal, who kept a menagerie (a private zoo) in Kolkata (then known as Calcutta) in the late eighteenth century. She hired three different artists trained in the Mughal style to make life-sized paintings of her exotic animals.

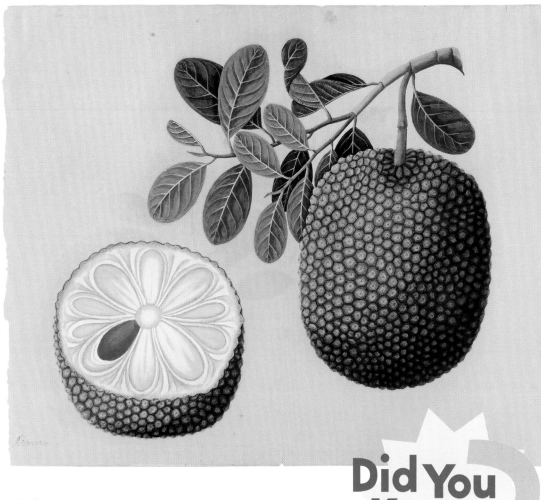

A Fruit to Remember

Following the Mughal tradition of observing plants and animals, Indian artists began to paint carefully studied animal and botanical specimens for British **patrons** in the eighteenth century. Officers of the **British East India Company commissioned** paintings of fruits, vegetables, and animals, painted from close—even scientific—observation. Many of these paintings were included in natural history books to document the large variety of species in India. This painting of a jackfruit, a large fruit native to Southern India, captures its texture and details. We also can see how volume is shown through **modeling** the fruit with light and shadow, which was a new technique Indian artists perfected while working in the Company style.

Did You Know?

Jackfruit has been important to Indian agriculture and cuisine for centuries. It is one of the largest types of fruit in the world and can grow to nearly one hundred pounds!

Your Turn

A Botanical Illustration

On page 11 of the enclosed sketchbook, create a detailed drawing of a leaf, plant, or piece of fruit. Looking carefully at the object, copy its shape and texture as closely as possible.

Animal Kingdoms

Animals play a very important role in Indian culture and **mythology**. Animals like the peacock and the lion, which appear often in imperial paintings, are **symbols** of royalty. Mighty elephants have been used for battle and processions, horses for transportation and warfare, and falcons and dogs for hunting birds, antelope, boars, and other animals. If we look closely, we can find many different animals in Indian art, and understand their significance to Indian culture. We can find creatures of all shapes and sizes in works of art from India, from real species to imaginary beasts from **Hindu** mythology.

Heavy Haulers

In this nineteenth-century painting from Southern India, a nobleman is riding in a bullock cart, an ox-drawn vehicle that served as a staple for transportation and farming in India. Bullock carts are still common in India today.

A Noble in a Bullock Cart with Canopy, Southern India, Tamil Nadu, ca. 1850

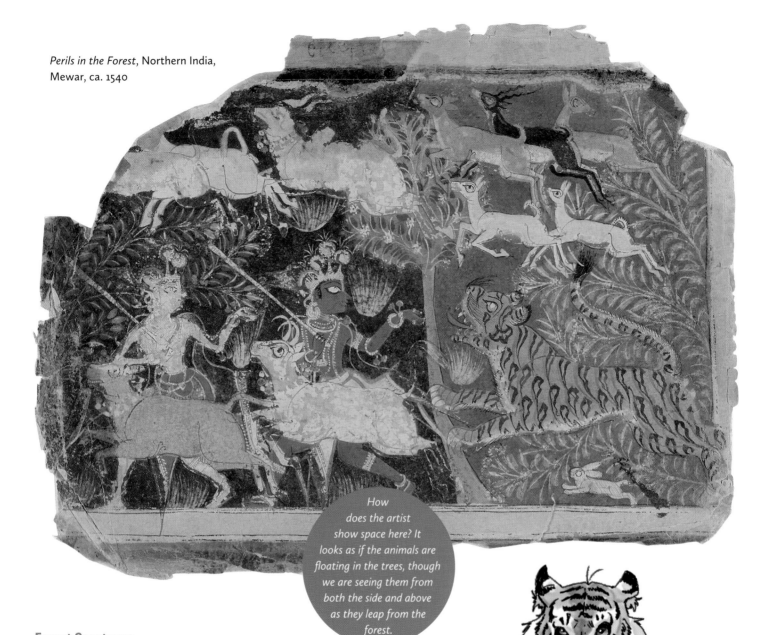

Perils in the Forest, Northern India, Mewar, ca. 1540

How does the artist show space here? It looks as if the animals are floating in the trees, though we are seeing them from both the side and above as they leap from the forest.

Forest Creatures

This illustration from a Hindu text shows a scene from the life of **Krishna** (see page 22), who overcame frightening obstacles such as facing the almighty tiger. Here, the tiger springs from the forest and startles the cattle Krishna attends to, along with deer, antelope, and other forest creatures. Krishna and the cowherd with him both run, glancing back toward the tiger in pursuit.

Did You Know?

The tiger is the national animal of India. Hunting and deforestation have reduced Bengal tiger populations so they are now an endangered species.

Holy Cows

Under Hindu belief, all animals are sacred, but none is more important than the cow. Krishna is said to have spent his childhood as a cowherd and was referred to as Govinda, meaning protector of cows, and the bull Nandi is the mount of Shiva (see page 23). Today in India, cows often roam free. Until recently, some forty thousand cows wandered the streets of Delhi. As cities have become more crowded, cows are herded and sent to protected reserves.

Awesome Elephants

Elephants hold a very important place in Indian society and history, and are a recurring subject in Indian art and religion. They would be dressed up in jewels or painted with decorations as a dramatic form of transportation for royalty in processions. Elephants were also favored by kings for use in battle. In this seventeenth-century painting, a raja (king) is riding a royally dressed elephant, with an attendant waving a fly whisk over him. There are elephant celebrations in India today; an annual festival in Jaipur features painted elephants decked out in fine costumes.

A Raja Riding an Elephant, Northern India, Bundi, ca. 1690

In South Asia, a person who works with and rides elephants is called a mahout.

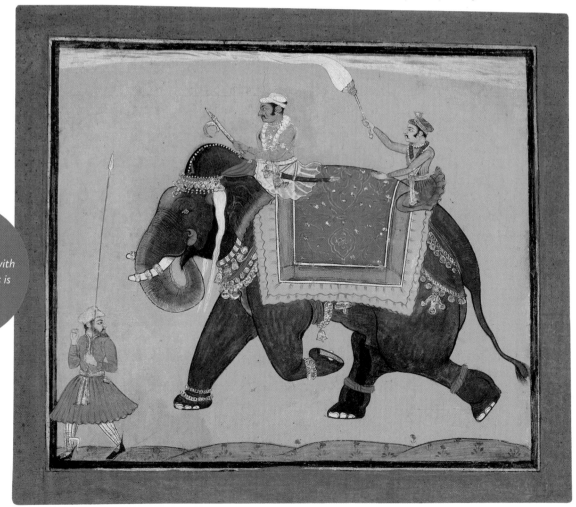

71

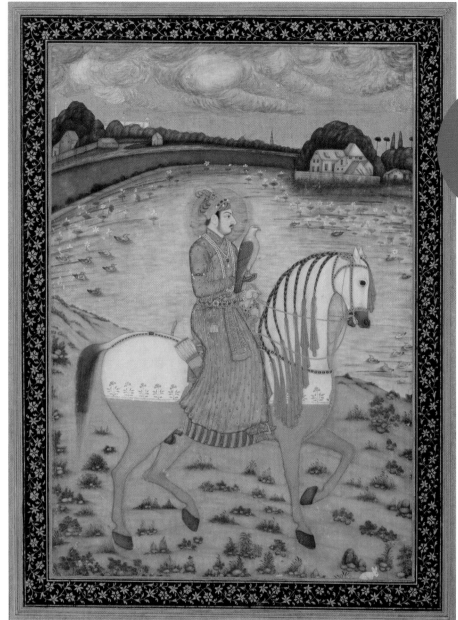

The Emperor Ahmad Shah in the Hunting Field, Northern India, ca. 1720

The emperor carries a falcon, which helped in hunting and also served as a symbol of royalty.

Did You Know?

Many different types of horses were bred in India, from stocky ponies to fast and agile Arabians. Thoroughbreds, used in racing and for playing polo (see page 56), were introduced to India from Britain.

No Horsing Around

Many royal **portraits** feature kings or nobles with equally regal-looking horses. The Mughal emperor Ahmad Shah, who ruled from 1748 to 1754, rides a fine Arabian horse through a fanciful setting. The horse has been painted with exquisite decorations, probably with henna, a plant that produces a reddish-orange **pigment** used to dye the skin and hair of both humans and animals.

Can You Find?

A rabbit

Did You Know?

Only the male birds have the long, showy tail feathers that the species is known for, which are now illegal to buy or sell in India.

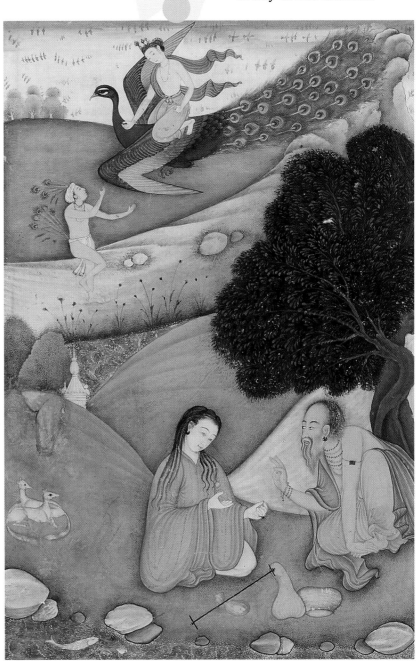

Royal Birds

The peacock, a symbol of royalty and beauty, is the national bird of India. Peacocks were kept in royal gardens to add splendor, and made exotic gifts to members of royal courts across Asia and Europe. In addition to their beauty, peacocks served a practical purpose in royal gardens as they helped control against pests. Peacocks also have a place in Hindu mythology. In this painting, a young **yogini** is listening to an old man telling a tale of the god Karttikeya, one of Shiva's sons, who appears on the back of a splendid peacock.

Your Turn

Imaginary Creatures

Indian art is full of animals, both real and imagined. On page 13 of the enclosed sketchbook, make your own creature by combining features from real animals or from your imagination.

The Aged Recluse Speaks to Mriganka, Northern India, ca. 1600

All that Glitters
The Art of Jewelry and Textiles in India

Rulers and other royalty of India have had a long-standing passion for jewelry and finery. Fine **textiles** have been hand-woven in India for centuries, and became popular export items to Europe. The **Mughals**, with their love of luxury and extravagance, perfected the art of jewelry-making. Strings of pearls, rubies, emeralds, and diamonds appeared in art throughout the Mughal period. Each stone has **symbolic** significance, with rubies representing the sun and pearls for the moon, for example. Many paintings feature members of the royal court decked out in elaborate jewels and fine clothing, as **symbols** of status and wealth.

Head-to-Toe Jewels

In India, women often wear their wealth in jewelry. Popular jewelry fashions include nose rings, ankle bracelets, and hair decorations (*tikli*). Even today in India, jewelry is very important and many families invest in as much jewelry as they can afford.

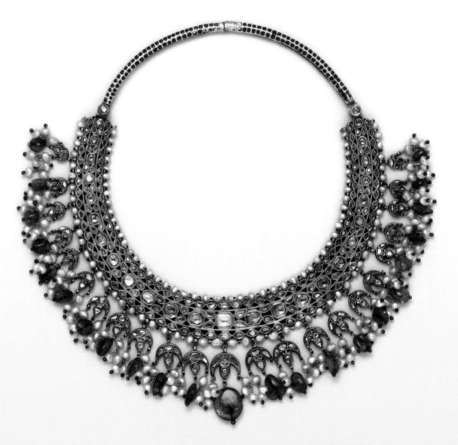

Necklet, Northern India, ca. 1850,
©Victoria and Albert Museum, London

Lovers by a Tree, Northern India, Delhi, ca. 1725

Fancy Threads

This couple's jewelry is complemented by fine clothing typical of Northern Indian fashions of the eighteenth century. The woman wears an elegant *peshwaz* (dress) and a fine *duppata* (veil), while the man wears a *jama* (overdress) tied with a *patka* (sash) decorated with elegant **motifs**, and both wear **embroidered** *paijama* (pants) and fancy *papush* (slippers).

Even the woman's anklets are lined with pearls and emeralds.

A flask of wine with a little cup

Can You Find

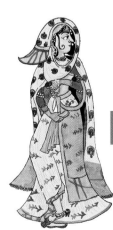

Did You Know

Traditional **Hindu** dress is an elegant *sari* for a woman and a *dhoti* for a man. Both men and women wear typically wear bright and colorful fabrics, even today.

Shawl, Northern India, Kashmir, 1840–60

*Can you see the repeating **patterns** in this shawl design?*

A high-quality embroidered shawl could take as long as three years to produce. Woven shawls with similar designs took about three times longer to make—up to six years!

Did You Know?

Wrapped in Luxury

Among the most popular textiles exported from India, Kashmiri shawls (from the region of Kashmir), like the one pictured here, were luxury products made from very fine wool. By the late eighteenth century, production of shawls was a thriving industry and Kashmiri merchants supplied fancy shawls, which were in high demand by European women. This shawl is made out of hundreds of pieces of wool of different colors that were patched together by a *rafugar* (a tailor or seam-sewer). Then **embroidery** was done on top in spiraling motifs.

Today in Kashmir, pashmina (a fine-quality material made from goat's wool) shawls have become popular and are much easier to make than traditional Kashmiri shawls.

Weaver's Work

Indian artists captured scenes of life among the different **castes** (Hindu classes of people)—people creating art, tending to animals, or doing other daily routines. Here, a man is working on a weaving at a **loom** while a woman spins thread on a wheel. The man holds a **shuttle** (device around which thread is wrapped) containing the **weft**, strings that are woven perpendicularly through the **warp** strings. In his other hand, he uses a tool called a **beater** to pack the weft strings closer together. The finished fabric would then be dyed with vegetable or plant dyes into bright colors, or stamped with a **printing** block to make a pattern.

Can You Find?

A hen with three baby chicks

What kind of textile do you think this man is weaving?

The Weaver's Courtyard, Northern India, Punjab, ca. 1850

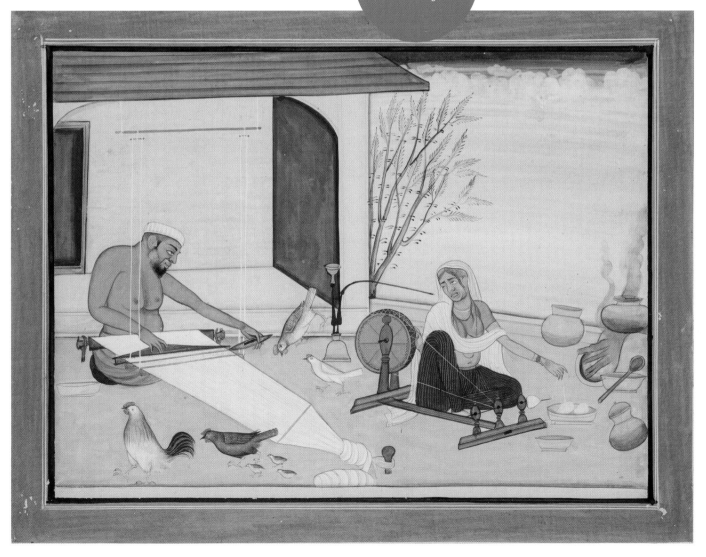

Magical Melodies
Music in Indian Painting

India has distinct musical traditions that extend back to ancient times, and music remains an important part of life in India today. Traditional Indian music consists of Hindustani music in the north and Carnatic in the south. Musicians often appear in Indian paintings in scenes of royal entertainment. Indian kings hired court musicians and composers, and sometimes ordered scenes featuring music to be painted directly on the palace walls. Some paintings feature scenes that evoke the same emotions intended in the performance of musical compositions (*ragas* and *raginis*). The verse, title of the painting, and the musical key all share the same name. *Ragamalas* (A Garland of Melodies), as series of these musical paintings were known, became very popular after the sixteenth century, and thousands of paintings were created to illustrate musical modes.

What do you think the music this ensemble is playing sounds like?

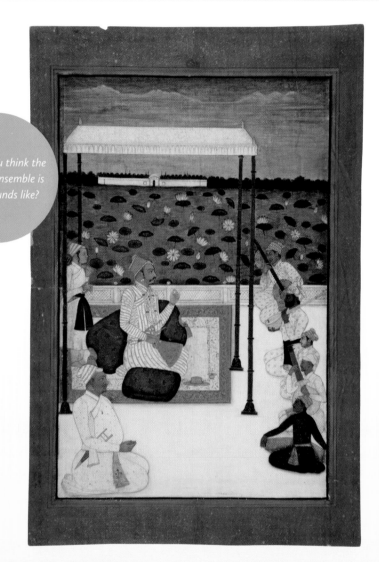

A Nobleman Listens to Music under a Canopy on a Terrace by a Lake, Northern India, Kishangarh, ca. 1680

Did You Know?

The Mughal Emperor Muhammad Shah was a major patron of the arts and made many innovations in music in the eighteenth century. The tabla (set of hand drums) became an important court instrument under his influence and the sitar (popular stringed instrument) was updated to its modern form.

Gaurmalar Ragini of Megh, Northern India, Jaipur, ca. 1720

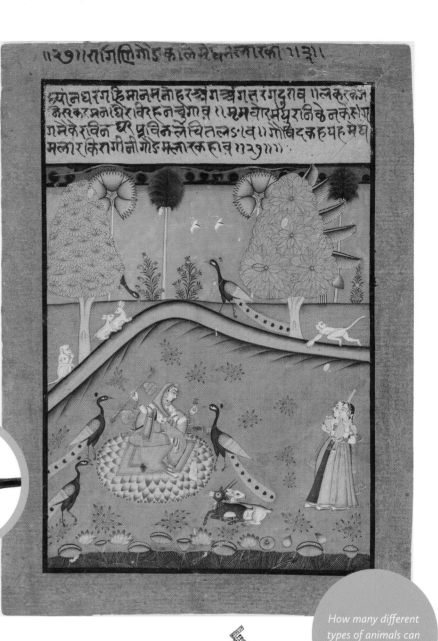

Royal Musicians

Celebrated musicians, poets, and dancers were entertainers at royal courts. Knowledge of music was seen as an important social skill, and commissioning a painting demonstrated a ruler's cultured status. In the painting on the left, a nobleman snaps along to a tune played by a court band. A variety of instruments are being played here, including the vina (an ancient plucked stringed instrument made from two hollow gourds connected by a wooden neck) at top, a tanpura and a sarod (stringed instruments), and a pakhavaj (two-headed drum).

Can You Find

Five peacocks

How many different types of animals can you see?

The Sound of Loneliness

In this *ragini*, a woman seated on lotus blossoms plays the vina in a wooded landscape. Having been separated from the person she loves, her music is tinged with sadness. She becomes surrounded by wild animals who are soothed by her song. We can imagine what the melody must have sounded like that accompanied this painting.

Did You Know

Ancient empires also had a love of music. An early form of the vina used during the Gupta period (see page 11) resembled a bowed harp with strings plucked with both hands, and King Samudragupta even had a picture of it imprinted on his gold coins.

India is home to many colorful religious celebrations and festivals that occur throughout the year. Marriages, birthdays, and other events are often a cause for great celebration in India as well. **Hindus** celebrate the **Diwali** festival each fall, which has been observed for centuries as a festival of lights, while the springtime **Holi** festival invites play and joy. The **Shab-e-Barat**, an annual **Muslim** festival, is a night of forgiveness and celebration, and the end of **Ramadan** (a month of fasting) is celebrated with a day of feasting called Eid al-Fitr. We can find images of celebration in Indian paintings and learn about some of the country's religious festivals and customs.

A Fiery Festival

Diwali, the festival of lights, is one of the most popular festivals in South Asia. It is celebrated by Hindus as the victory of good over evil, and today stands for hope and a celebration of the joys in life. Small earthenware oil lamps called *diyas* are placed in rows. According to Hindu legend, the lamps help **Lakshmi**, the goddess of wealth (see page 24), find her way into people's homes, and they also celebrate the return of **Rama** and **Sita** in the *Ramayana* (see page 32).

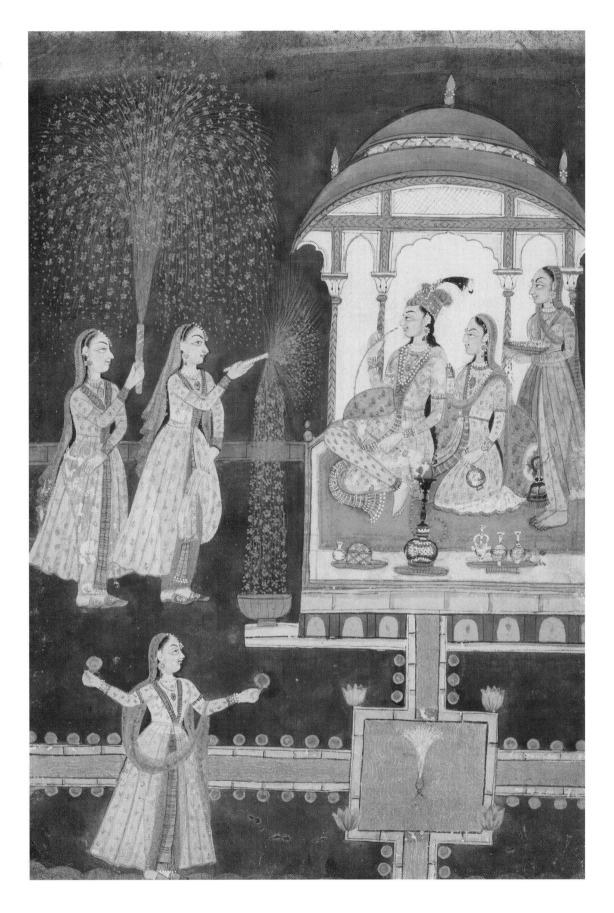

Two Women Sit beneath a Pavilion and Watch the Fireworks Held by Three Maids, Central India, Hyderabad, ca. 1730

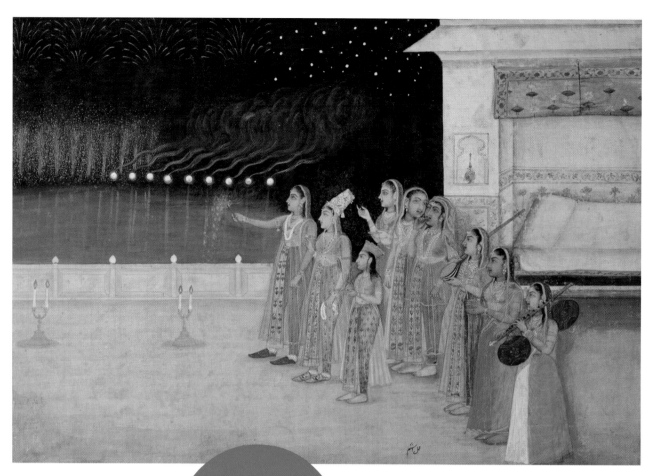

Hashim, *Celebrating with Fireworks*, Northern India, ca. 1735

Night of Lights

In this painting of fireworks, a **Mughal** princess and her attendants could be celebrating the Shab-e-Barat. To mark the festivities, thousands of candles and strands of lanterns light up houses and streets, and fireworks are displayed. People attend prayer, recite passages from the **Quran** and sing spiritual songs. Though this appears to be a festive and joyous moment, there was not much cause for celebration at the time this was painted— the Mughal Empire was nearing collapse, and its capital at Delhi would be captured in 1739 by the **Persian** Nader Shah.

Did You Know?

When festivities exhausted the city's stock of oil, lamps would be filled with butter!

Holi Days

The ancient festival of Holi, associated with love and play, occurs in the spring in India. During this colorful and joyous tradition, people throw colored powders and squirt colored water at each other. In this painting, a prince and his companion are participating in Holi with women of the court. The lively festivities are marked by music, as a woman plays the tabla (a set of hand drums). We can see the fun that they have had—brightly colored water has been splashed all over the palace terrace and walls.

What is your favorite festival or celebration?

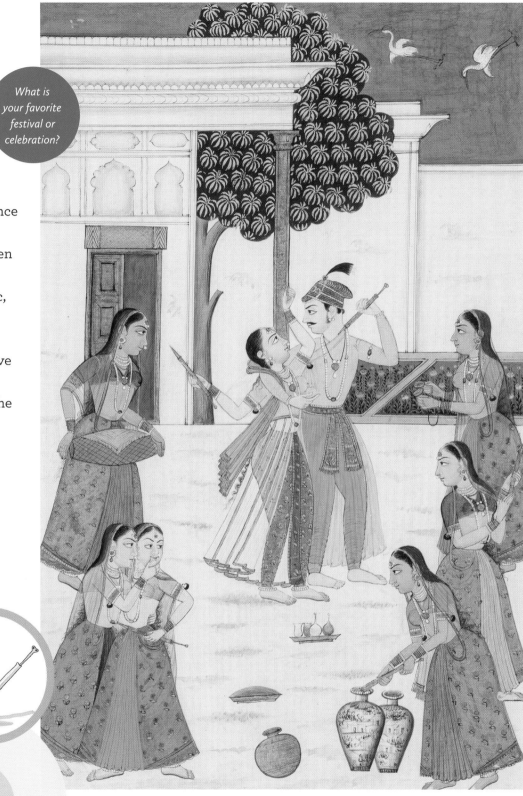

Vasanta Ragini of Sri (Holi), Central India, Hyderabad, ca. 1745

Can You Find

A woman reloading with colored water

15 Artists Today
Modern and Contemporary Indian Painting

What have artists from India and other regions of South Asia created in more recent times? **Modern** and **contemporary** artists have made significant contributions to art. Nandalal Bose, one of the main pioneers of modern Indian art in the early twentieth century, was inspired by Indian traditional art and portrayed themes of village life and **Hindu mythology** in his work. Jamini Roy, another important Indian artist of the twentieth century, became inspired by Hindu themes and the village art of Bengal. Shazia Sikander, a contemporary artist who lives and works in New York, is native to Pakistan and trained in traditional Indian **miniature painting** techniques at the National College of Arts in Lahore. She mixes ancient techniques and imagery from Indian paintings with themes from contemporary life.

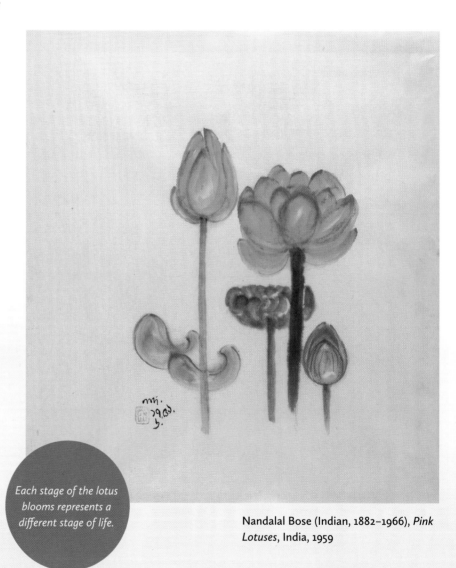

Each stage of the lotus blooms represents a different stage of life.

Nandalal Bose (Indian, 1882–1966), *Pink Lotuses*, India, 1959

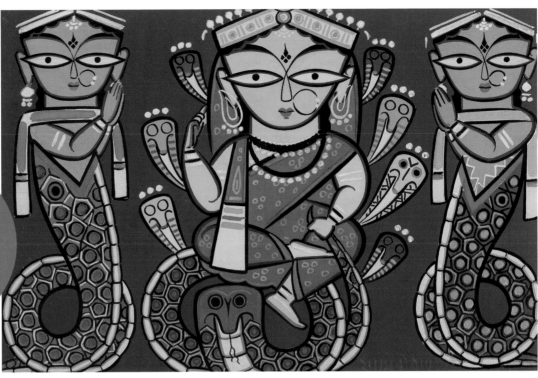

Jamini Roy (Indian, 1887–1972), *Manasa, the Snake Goddess*, Eastern India, Kolkata, ca. 1920

How does this painting compare to other Indian paintings that you have seen in this book? What are some similarities and differences?

A New Take on an Old Tradition

Nandalal Bose was responsible for reviving Indian art, which had been mostly lost during British colonial rule (see page 62), and continued the traditions that artists in India began more than two thousand years ago. He also turned to nature and landscape painting in *sumi-e* (Japanese technique of brush painting) inspired by East Asian traditions. The lotus flower has been an important **symbolic** image in Indian art for centuries, often associated with **Vishnu** and his **consorts** (companions) in Hindu mythology, and **Buddha** is often shown sitting on a lotus flower in **meditation**. Lotuses grow in bodies of water and are **symbols** of purity and life.

The Snake Goddess

Jamini Roy explored traditional Indian themes, but gave them a new spin with a modern style. He only used seven colors in his **palette** to give his work an authentic feel. The snake goddess Manasa comes from Bengali devotional practices. She is believed to help cure snakebites and other infections and is worshipped for prosperity and fertility. Manasa **symbolizes** both destruction and renewal, just as a snake molts to reveal new skin.

Did You Know?

Nandalal Bose illustrated the Indian constitution, which was adopted in 1950.

Your Turn

Fill in the Features

On page 15 of the enclosed sketchbook, add **patterns**, textures, and details to the image using traditional Indian colors.

करकेमोरेकुसुमलोगईविरहकुँभिलाऊ मराममोंपिनमविनहॅनौठिपिछ नीन्नाऊ पिधरी

Krishna Learns of Radha Wilting Like a Flower, Northern India, Mewar, 1719

Shahzia Sikander (American and Pakistani, born 1969), *To Mistake*, United States, 2004

The lotus flower

Can You Find

Made a Mistake

How can an ancient story be reimagined through contemporary art? In one of nineteen works Shahzia Sikander created based on seventeenth-century **Deccani** miniatures in The San Diego Museum of Art's collection, she retells a moment in the tale of **Krishna** and **Radha**'s love. In the original story from the *Gita Govinda*, Radha falls deeply in love with Krishna and becomes very upset when she believes Krishna does not return her love for him. When Krishna learns of Radha's disappointment, he realizes that he made a mistake and their love is confirmed.

Can you see how elements from the original work that inspired Sikander are transformed? She takes a different approach to illustrating the same moment in her painting by moving the figures around and changing the setting.

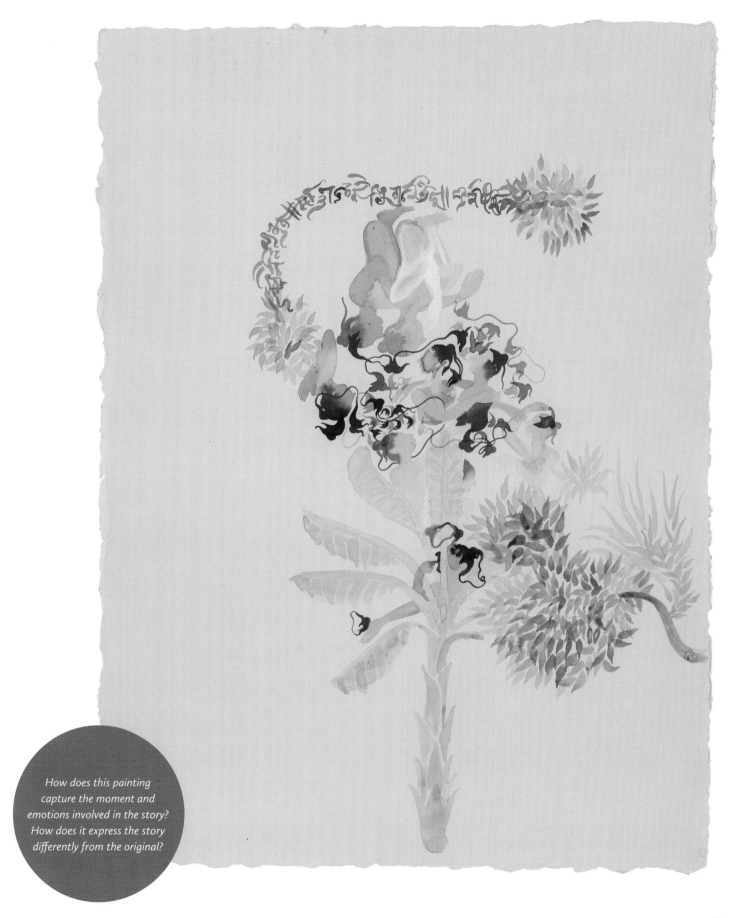

How does this painting capture the moment and emotions involved in the story? How does it express the story differently from the original?

Timeline

Shiva as Lord of Music 6th century

Islam introduced to India

ca. 700

Shri Devi 11th century

Prince Siddhartha lived; Buddhism founded

ca. 563–486 BC

Jainism founded

ca. 500 BC

Earliest hymns of the Vedas, sacred Hindu texts, composed

ca. 1800–1000 BC

Gupta Empire

ca. 300–500

Chola Empire

ca. 850–1279

1000 BC **500 BC** **500 AD** **1000–1100 AD** **1200–1300 AD**

Silk Road established

100 BC

Maurya Empire

ca. 322–185 BC

Prince Siddhartha Leaves the Palace ca. 300 BC

Buzurjmihr Invents the Game of Backgammon and Shows How It Is Played ca. 1500

Alexander of Macedon invades northern India

330 BC

Quran Page ca. 1400

Sikhism founded

ca. 1400–1500

Delhi Sultanate

1206–1526

Wodeyar (Wadiyar) dynasty rules kingdom of Mysore

1399–1947

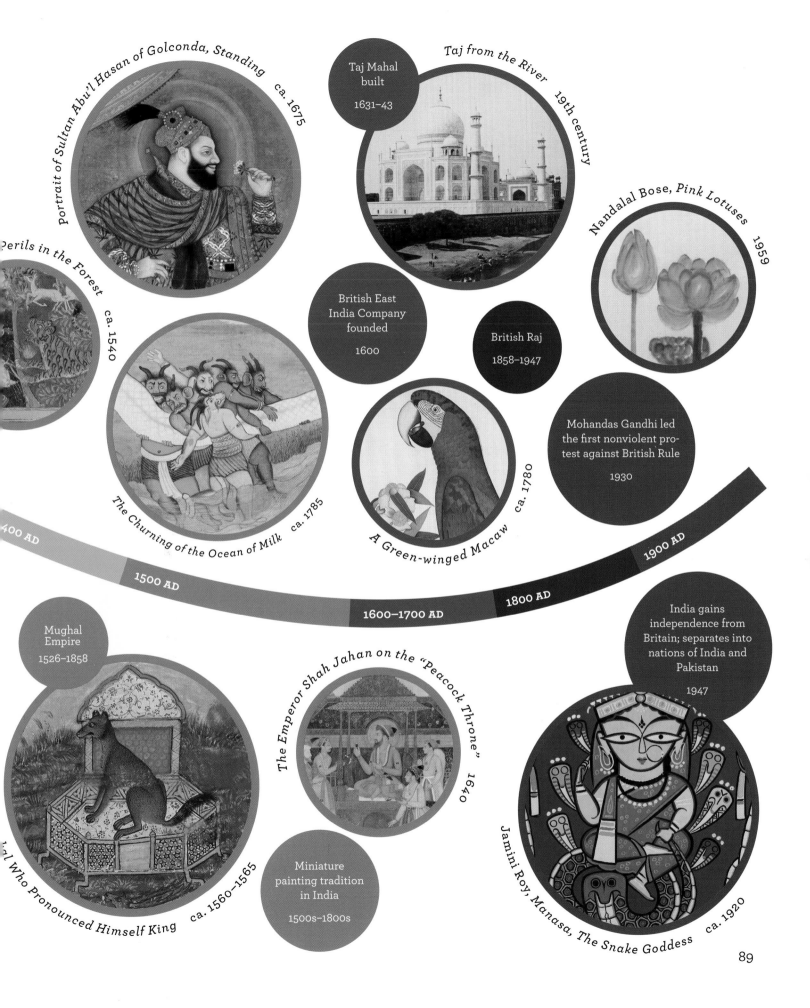

Portrait of Sultan Abu'l Hasan of Golconda, Standing ca. 1675

Taj Mahal built

1631–43

Taj from the River 19th century

Perils in the Forest ca. 1540

Nandalal Bose, Pink Lotuses 1959

British East India Company founded

1600

British Raj

1858–1947

Mohandas Gandhi led the first nonviolent protest against British Rule

1930

The Churning of the Ocean of Milk ca. 1785

A Green-winged Macaw ca. 1780

400 AD

1500 AD

1600–1700 AD

1800 AD

1900 AD

India gains independence from Britain; separates into nations of India and Pakistan

1947

Mughal Empire

1526–1858

...al Who Pronounced Himself King ca. 1560–1565

The Emperor Shah Jahan on the "Peacock Throne" 1640

Miniature painting tradition in India

1500s–1800s

Jamini Roy, Manasa, The Snake Goddess ca. 1920

Checklist

All works are in the collection of The San Diego Museum of Art except those marked with an asterisk (*).

The Battle between Arjuna and His Guru, Dronacharya. Southern India, Mysuru, 1670. Opaque watercolor and gold on paper, 8 × 14½ in. Edwin Binney 3rd Collection, 1990.1399 (page 7)

Shiva as Lord of Music. Western India, Gujarat, 6th century. Sandstone, 16¾ × 13¾ × 4¾ in. Edwin Binney 3rd Collection, 1990.144 (page 11)

Standing Bodhisattva. Pakistan, ancient Gandhara, ca. 3rd century. Schist, 33 × 14 × 6 in. Purchased with Resale Funds and with Funds provided by the Asian Arts Committee and dedicated to Julia Andrews and Margaret Robbins, who made great contributions of their considerable talents to the Committee and to the San Diego Museum of Art, 1980.2 (page 12)

Prince Siddhartha Leaves the Palace. Pakistan, ancient Gandhara, 2nd–3rd century. Schist, 10¾ × 18 × 2½ in. Museum purchase with funds provided by The Asiatic Arts Committee of the Fine Arts Gallery in memory of Charles Fabens Kelley, 1960.7 (page 13)

The Ten Sikh Gurus Seated in a Circle under a Tree. Pakistan, Lahore, ca. 1840. Opaque watercolor and gold on paper, 11⅜ × 9¼ in. Edwin Binney 3rd Collection, 1990.1347 (page 14)

The Churning of the Ocean of Milk. Northern India, Kangra, ca. 1785. Opaque watercolor and gold on paper, 7⅛ × 10⅞ in. Edwin Binney 3rd Collection, 1990.1271 (page 15)

Quran Page. Northern India, ca. 1400. Ink and gold on paper, 23⅜ × 13½ in. Edwin Binney 3rd Collection, 1990.255.1 (page 16)

The Buddha in the Earth-Touching Gesture. Northeastern India, Bihar, 10th century. Schist, 10¾ × 8 × 4 in. Museum purchase with funds provided by the Asian Arts Council, 1960.58 (page 17)

Two Worshippers in the Moti Masjid (Pearl Mosque), Agra. India, ca. 1870. Albumen print, 8⅛ × 11 in. Museum purchase from the Catherine Glynn Benkaim and Barbara Timmer Collection with funds provided by the Beatrice Lynds Bequest, 2010.209 (page 18)

Altarpiece with Vishnu and Shri Devi. Central India, Madhya Pradesh, ca. 9th century. Bronze, 12¼ × 7 in. Museum purchase with Kenneth Brown Memorial Funds, Earle W. Grant Art Acquisition Funds, the Beatrice Lynds Bequest, and Asian Arts Council Funds, 2010.25 (page 19)

A Scene in a Jain Temple. Northern India, Marwar, 1824. Opaque watercolor and gold on paper, 17⅛ × 21⅝ in. Edwin Binney 3rd Collection, 1990.827 (page 20)

Krishna Flutes under a Tree. Northern India, Kishangarh, ca. 1690. Opaque watercolor and gold on paper, 9½ × 8 in. Edwin Binney 3rd Collection, 1990.747 (page 22)

Lord Shiva Attended by Parvati. Northern India, Jaipur, ca. 1770. Opaque watercolor and gold on paper, 11 × 8⅔ in. Edwin Binney 3rd Collection, 1990.862 (page 23)

Ganesh. India, undated. Soapstone, 2¼ × 1½ × ½ in. Bequest of Harriet Sefton Campbell, 1938.212.a (page 23)

Shri Devi. Southern India, Tamil Nadu, 11th century. Bronze, 28 × 11½ × 7½ in. Museum purchase with funds provided by the Beatrice Lynds Bequest, 2004.3 (page 24)

Krishna Approaches the Citadel of Naraka. Northern India, Bikaner, ca. 1710. Opaque watercolor and gold on paper, 8⅞ × 12 in. Edwin Binney 3rd Collection, 1990.785 (page 25)

The Demon Dhumraksha Leads his Army. Northern India, Kulu, ca. 1705. Opaque watercolor on paper, 9 × 13¼ in. Edwin Binney 3rd Collection, 1990.1107 (page 26)

Demons in a Wild Landscape. Northern India, ca. 1600. Opaque watercolor and gold on paper, 8⅜ × 4⅞ in. Edwin Binney 3rd Collection, 1990.302 (page 27)

**Painters and Calligraphers Working.* An illustration from the *Akhlaq-i-Nasiri* of Nasir ud-Din Tusi, ca. 1559–95. Prince Sadruddin Aga Khan Collection (page 29)

Kripal, *Delighted at the Prospect: The Nayika Mudita.* Northern India, Nurpur or Basohli, ca. 1665. Opaque watercolor, gold, silver, and beetle cases on paper, 9⅜ × 13⅛ in. Edwin Binney 3rd Collection, 1990.1039 (page 30)

Sampati Reveals Sita's Location. Northern India, Garhwal, ca. 1840. Opaque watercolor and gold on paper, 10½ × 13¼ in. Edwin Binney 3rd Collection, 1990.1325 (page 33)

The Salvation of the King of the Elephants. Northern India, Bundi, ca. 1770. Opaque watercolor on paper, 9⅜ × 7¼ in. Edwin Binney 3rd Collection, 1990.687 (page 34)

The Jackal Who Pronounced Himself King. Northern India, ca. 1560–65. Opaque watercolor and gold on paper, 6¼ × 4 in. Edwin Binney 3rd Collection, 1990.273 (page 35)

'Abid, son of Aqa Riza, *The Emperor Shah Jahan on the "Peacock Throne."* Northern India, 1640. Opaque watercolor and gold on paper, 14⅜ × 9⅞ in. Edwin Binney 3rd Collection, 1990.352 (page 37)

Bowl with Lotus Bud Handles. India or China, 18th century. Jade, 1⅝ × 5⅝ × 4¾ in. Gift of the Harold B. Canavan Family, 1988.1 (page 38)

Bhawanidas, *A Gathering of Princes.* Northern India, ca. 1710. Opaque watercolor and gold on paper, 11⅞ × 7¾ in. Edwin Binney 3rd Collection, 1990.365 (page 39)

*****Samuel Bourne** (British, 1834–1912), *Taj from the River.* India, 1865. Albumen print, 9 × 11⅜ in. Promised gift from the Catherine Benkaim and Barbara Timmer collection (page 40)

*****"Taj Mahal in Sunrise Light, Agra, India."** saiko3p/Shutterstock (page 41)

*****"Taj Mahal Building Details at Agra, Uttar Pradesh, India."** Alexander Mazorkevich/Shutterstock (page 41)

*****"Marble Inlay."** palmmetto/Shutterstock (page 41)

Maharana Sangram Singh with His Children and Courtiers. Northern India, Mewar, ca. 1715. Opaque watercolor and gold on paper, 16⅛ × 26¾ in. Edwin Binney 3rd Collection, 1990.619 (page 43)

Chokha, *Maharana Bhim Singh Returns from the Hunt.* Northern India, Mewar, 1803. Opaque watercolor and gold on paper, 20¾ × 12⅝ in. Edwin Binney 3rd Collection, 1990.640 (page 44)

Gobind, *The Darbar of Raja Bakhtawar Singh of Alwar.* Northern India, Alwar, ca. 1810. Opaque watercolor and gold on paper, 21 × 27⅞ in. Edwin Binney 3rd Collection, 1990.918 (page 45)

Portrait of Sultan Abu'l Hasan of Golconda, Standing. Central India, Golconda, ca. 1675. Opaque watercolor and gold on paper, 8⅝ × 5⅝ in. Edwin Binney 3rd Collection, 1990.491 (page 47)

Muhammad Adil Shah Selects a Jewel. Central India, Bijapur, ca. 1650. Opaque watercolor and gold on paper, 9 × 11¼ in. Edwin Binney 3rd Collection, 1990.443 (page 48)

Krishnaraja Wodeyar III Worships the Goddess Chamundeshvari. Southern India, Mysuru, 1859. Lithograph, 7¼ × 11⅝ in. Edwin Binney 3rd Collection, 1990.1404 (page 49)

Shish Mahal, Amber Palace, Jeypore. India, ca. 1890. Albumen print, 9¼ × 11⅛ in. Museum purchase from the Catherine Glynn Benkaim and Barbara Timmer Collection with funds provided by the Beatrice Lynds Bequest, 2010.220 (page 51)

Princess and Companions on a Moonlit Terrace. Northern India, Lucknow, ca. 1760. Opaque watercolor and gold on paper, 16 × 11¾ in. Edwin Binney 3rd Collection, 1990.411 (page 52)

Pierced Screen. Northern India, early 17th century or later. Sandstone, 50 × 31⅜ × 2⅛ in. Museum purchase, 1998.105 (page 52)

Jai Ram, *Maharana Jagat Singh II Frolics in a Palace Pool.* Northern India, Mewar, ca. 1746–50. Opaque watercolor and gold on paper, 18½ × 32 in. Edwin Binney 3rd Collection, 1990.624 (page 54)

Mir Miran, *Queen Udham Bai Entertained.* Northern India, 1742. Opaque watercolor and gold on paper, 10¾ × 12⅞ in. Edwin Binney 3rd Collection, 1990.383 (page 55)

Six Polo Players on the Field. Central India, Golconda, ca. 1585. Opaque watercolor and gold on paper, 6⅞ × 4½ in. Edwin Binney 3rd Collection, 1990.471 (page 56)

Buzurjmihr Invents the Game of Backgammon and Shows How It Is Played. Northern India, ca. 1500. Opaque watercolor and gold on paper, 7⅝ × 6 in. Edwin Binney 3rd Collection, 1990.240 (page 57)

Abu'l Hasan, *Emperor Jahangir with Holy Men in a Garden.* Northern India, ca. 1615 (album page 18th century). Opaque watercolor and gold on paper, 12⅞ × 7⅝ in. Edwin Binney 3rd Collection, 1990.345 (page 59)

*****"Shalimar Bagh."** saiko3p/Shutterstock (page 60)

Radha and Krishna Pick Lotuses from a Lake. Northern India, Kishangarh, ca. 1755. Opaque watercolor and gold on paper, 12⅛ × 8⅜ in. Edwin Binney 3rd Collection, 1990.757 (page 60)

Akbar Shah II Receives the British Resident. Northern India, ca. 1810. Opaque watercolor and gold on paper, 17¾ × 15⅝ in. Edwin Binney 3rd Collection, 1990.394 (page 63)

***Samuel Bourne** (British, 1834–1912), *Shipping Boats in the Hooghly River from Fort Point*. India, 1867. Albumen print, 7¼ × 12¼ in. Promised gift from the Catherine Glynn Benkaim and Barbara Timmer collection (page 64)

Laxmi Narayan, *Thakur Sahab Samadr Karanji with Kabraji Mukandra Karanji Sahab and Bhao Raj Cha*. Northern India, Jaipur, ca. 1875. Opaque watercolor and gold on paper, 10⅝ × 13¾ in. Edwin Binney 3rd Collection, 1990.650 (page 65)

A Himalayan Cheer Pheasant. Northern India, ca. 1620 (border ca. 1635). Opaque watercolor and gold on paper, 8⅛ × 5¼ in. Edwin Binney 3rd Collection, 1990.342 (page 67)

Shaikh Zayn al-Din, *A Green-winged Macaw*. Eastern India, Kolkata, ca. 1780. Opaque watercolor on paper, 35¼ × 22⅜ in. Edwin Binney 3rd Collection, 1990.1357 (page 67)

Jackfruit and Foliage. Eastern India, Kolkata, ca. 1815. Opaque watercolor on paper, 18½ × 23⅛ in. Edwin Binney 3rd Collection, 1990.1381 (page 68)

A Noble in a Bullock Cart with Canopy. Southern India, Tamil Nadu, ca. 1850. Opaque watercolor and gold on paper, 8⅞ × 12½ in. Edwin Binney 3rd Collection, 1990.1433 (page 69)

Perils in the Forest. Northern India, Mewar, ca. 1540. Opaque watercolor on paper, 7 × 9¼ in. Edwin Binney 3rd Collection, 1990.582 (page 70)

A Raja Riding an Elephant. Northern India, Bundi, ca. 1690. Opaque watercolor and gold on paper, 10¾ × 12½ in. Edwin Binney 3rd Collection, 1990.673 (page 71)

The Emperor Ahmad Shah, in the Hunting Field. Northern India, ca. 1720. Opaque watercolor and gold on paper, 11⅜ × 8⅛ in. Edwin Binney 3rd Collection, 1990.384 (page 72)

The Aged Recluse Speaks to Mriganka. Northern India, ca. 1600. Opaque watercolor and gold on paper, 11½ × 4⅜ in. Edwin Binney 3rd Collection, 1990.317 (page 73)

**Necklet*. Northern India, ca. 1850. Enameled gold, set with diamonds and pearls, with pendent pearls and emeralds, 7¾ diameter × 6¾ in. width. 03202(IS) ©Victoria and Albert Museum, London (page 74)

Lovers by a Tree. Northern India, Delhi, ca. 1725. Opaque watercolor and gold on paper, 11½ × 6¾ in. Edwin Binney 3rd Collection, 1990.382 (page 75)

Shawl. Northern India, Kashmir, 1840–60. Embroidered wool, 74½ × 73¼ in. Gift of Mrs. Paul Brandstedt, 1948.15 (page 76)

The Weaver's Courtyard. Northern India, Punjab, ca. 1850. Opaque watercolor on paper, 7¼ × 9⅝ in. Edwin Binney 3rd Collection, 1990.1398 (page 77)

A Nobleman Listens to Music under a Canopy on a Terrace by a Lake. Northern India, Kishangarh, ca. 1680. Opaque watercolor and gold on paper, 13¼ × 8⅝ in. Edwin Binney 3rd Collection, 1990.746 (page 78)

Gaurmalar Ragini of Megh. Northern India, Jaipur, ca. 1720. Opaque watercolor and gold on paper, 11¾ × 8¾ in. Edwin Binney 3rd Collection, 1990.855 (page 79)

Two Women Sit beneath a Pavilion and Watch the Fireworks Held by Three Maids. Central India, Hyderabad, ca. 1730. Opaque watercolor and gold on paper, 8 × 5½ in. Edwin Binney 3rd Collection, 1990.526 (page 81)

Hashim, *Celebrating with Fireworks*. Northern India, ca. 1735. Opaque watercolor and gold on paper, 6⅛ × 8¾ in. Edwin Binney 3rd Collection, 1990.374 (page 82)

Vasanta Ragini of Sri (Holi). Central India, Hyderabad, ca. 1745. Opaque watercolor and gold on paper, 9½ × 6⅛ in. Edwin Binney 3rd Collection, 1990.529 (page 83)

Nandalal Bose (Indian, 1882–1966), *Pink Lotuses*. India, 1959. Ink and colors on paper, 17 × 15½ in. Gift of Supratik Bose, 2006.191 (page 84)

Jamini Roy (Indian, 1887–1972), *Manasa, the Snake Goddess*. Eastern India, Kolkata, ca. 1920. Opaque watercolor on paper, 13½ × 20½ in. Edwin Binney 3rd Collection, 1990.1503 (page 85)

Krishna Learns of Radha Wilting Like a Flower. Northern India, Mewar, 1719. Opaque watercolor, ink, and gold on paper, 9⅞ × 8⅝ in. Edwin Binney 3rd Collection, 1990.617 (page 86)

Shahzia Sikander (American and Pakistani, born 1969), *To Mistake*. United States, 2004. Ink and gouache on paper, 15¼ × 11½ in. Museum purchase with funds provided by Safi and Anita Qureshey, 2004.205 (page 87)

Glossary

Atelier: Art studio

Altarpiece: A work of art set above or behind an altar of a church or temple

Architecture: The practice of designing and constructing buildings

Avatar: An embodiment on earth of a Hindu god or goddess

Beater: A tool used in weaving to pack the weft strings closer together to make a tight fabric or textile

***Bhagavata Purana* (Ancient Tales of the Lord Vishnu):** An ancient Hindu epic that describes the conquests of the god Vishnu and the story of his avatars

Biography: An account of someone's life

Bodhisattva: One of a group of enlightened beings who are important figures in the Buddhist religion

Botanical illustration: A detailed drawing of a plant species

Brahma: A creator god in Hinduism

British East India Company: A British company formed around 1600 to trade with India

British Raj: A period of British rule in India that lasted from 1858 to 1947

Buddha: The founder of the Buddhist religion

Buddhism: A religion that began in India around the fifth century BC that encompasses the teachings of Buddha to follow a path of meditation to achieve enlightenment (adjective: **Buddhist**)

Burnish: The technique of polishing an Indian painting by rubbing it with a smooth piece of agate (stone) (adjective: **burnished**)

Calligrapher: A person who practices calligraphy

Calligraphy: The art of decorative handwriting with a pen or brush

Caste: System of subdivisions among the four hierarchical classes of traditional Hindu society

Cenotaph: A monument commemorating someone who is buried elsewhere

Ceramic: An object that is made of clay and hardened by heating it

Chola Empire: The region of Southern India ruled by the Chola dynasty from the late ninth to early thirteenth century

Christianity: The religion based on the teachings of Jesus of Nazareth

Colonize: To settle and establish political control over a foreign land

Commission: To hire an artist to create a work of art

Company school: Paintings made by Indian artists for members of the British East India Company in a European realist or natural history painting style

Consort: A companion or spouse of a divinity or ruler

Contemporary art: Art of the present time

Continuous narration: The technique of showing multiple moments from a story in a single painting

Contrapposto: A technique that originated in ancient Greek art in which a figure's weight is shifted mostly onto one foot

***Darbar*:** A term for a royal assembly

Deccani school: A style of painting developed in the Deccan region of southwestern India under Muslim sultans in the sixteenth to seventeenth centuries; main centers of production were Ahmadnagar, Bijapur, Golconda, and Hyderabad.

Delhi Sultanate: A series of Islamic dynasties that ruled Northern India from 1206 to 1526

Demigod: A minor god

Dervish: A Muslim, specifically of the Sufi branch of Islam, who has taken vows of poverty for religious reasons

Devi: The Great Goddess; one of the main divinities of Hinduism

Divinity: A god or spiritual being

Diwali: The Hindu festival of lights celebrated in India and other places around the world

Durga: An incarnation of the Hindu goddess Devi; eight-armed warrior goddess who rides a lion

Dynasty: A family line of rulers

Embroidery: A cloth decorated with sewn patterns of threads (adjective: **embroidered**)

Enlightenment: A state of spiritual knowledge and insight in Buddhism

Epic: A long story or poem that often involves heroic deeds or history of nations

Foreground: The area of a painting or drawing that is closest to the viewer

Gandhara: An ancient kingdom, located in present-day Pakistan near the Afghanistan border, between the sixth century BC and eleventh century AD, known for a style of sculpture that combines Greco-Roman features with Buddhist themes

Ganesh: The elephant-headed Hindu god; son of Shiva and Parvati

Genre: A particular subject type in art

Gita Govinda **(Song of the Herdsman):** An extended lyric poem in Sanskrit on the life of Krishna, composed by the devotional poet Jayadeva in the twelfth century

Gold leaf: Gold that has been beaten into a very thin sheet and is applied to works of art in a process called gilding

Gouache: An opaque paint made from pigments, water, and a binding medium

Greco-Roman: Relating to the ancient Greeks and Romans

Gum arabic: A sticky substance from the acacia tree that binds pigments together used in the creation of opaque water-based paints

Gupta Empire: Empire established between 320 and 550 AD in northern India that extended to Pakistan and parts of Myanmar and Nepal; considered to be a golden age in Indian art and culture

Halo: A gold disc symbolizing spirituality or divine light

Hanuman: A semi-divine leader of forest-dwellers, depicted with the head and tail of a monkey and the body of a man; one of the heroes of the *Ramayana*

Hindi: A major north Indian language derived from Sanskrit

Hinduism: A major religion of South Asia, encompassing the worship of multiple gods and goddesses and a social caste system (adjective: **Hindu**)

Holi: A Hindu spring festival marked by tossing or shooting colorful waters and powders

Hue: A color

Illuminate: To decorate a page in a manuscript with color and/or gold designs (adjective: **illuminated**)

Incarnation: A god in the form of a human, animal, or creature

Islam: The religion of Muslims, who believe in god (Allah) as revealed through the prophet Muhammad in the seventh century AD (adjective: **Islamic**)

Jainism: An ancient religion founded in India in the sixth century BC; followers of the Jain religion promote nonviolence (*ahimsa*) and respect for all living beings

Krishna: The eighth incarnation of the god Vishnu and an important character in tales such as the *Bhagavata Purana* and the *Gita Govinda*

Kushan Empire: The empire ruled by a Central Asian dynasty that united Northern India from the end of the first century until the third century AD

Lakshmana: Rama's brother and one of the heroes of the *Ramayana*

Lakshmi: An incarnation of Devi, the Hindu Great Goddess; thought to bring abundance and wealth; consort of Vishnu

Lithograph: A print made from a smooth surface that is treated with grease to repel ink from certain areas

Loom: A device used to weave a cloth or tapestry

Mahabharata **(Great Epic of the Baharata Dynasty):** An important Hindu epic composed in written form around AD 350 that describes the battle between the Kauravas and the Pandavas

Maharana: A title given to a king

Manuscript: A book

Maurya Empire: The empire that covered much of India, Pakistan, Afghanistan, and Sri Lanka from 322 to 185 BC

Meditate: The spiritual practice of deeply relaxing and focusing one's mind (noun: **meditation**)

Medium: A liquid such as gum arabic, oil, or egg yolk that binds pigments together to make paint; can also refer to the material used to make a work of art

Minaret: A tall, slender tower of a mosque from which Muslims can be called to prayer

Miniature painting: Traditional painting in India that is created to be included in books or albums

Modeling: The art of creating or portraying a three-dimensional form

Modern art: Art created during the period of the late nineteenth until the mid-twentieth century

Monk: A member of a religious community who has taken a vow of obedience

Mosque: A Muslim place of worship and congregation

Motif: A decorative design that often repeats into a pattern

Mughal Empire: An empire established in India from 1526 to 1858 led by a dynasty from Central Asia, based primarily in northern India but expanded to unify much of India except the deep south during the period of its greatest extent

Mughal school: Style of painting that evolved in India under Mughal patronage during the sixteenth to eighteenth centuries, mostly in imperial court centers of northern India and Pakistan

Muhammad: The prophet of Islam who lived from AD 570 to 632

Muslim: A follower of Islam

Mythology: A collection of myths

Myth: An ancient story usually associated with a religion or set of beliefs meant to explain the creation of the world and other events

Narrative: A story told through a work of art

Pahari school: Style of painting in the seventeenth to nineteenth centuries made for rulers of the Punjab and Himalayan foothills in the northeastern region of India, at courts including Basohli, Kangra, and Guler

Palette: Range of colors used by an artist

Parvati: A Hindu goddess; the wife of Shiva

Patron: A person, often royalty in India, who commissions works of art

Pattern: A repeated decorative design

Persia: An ancient kingdom that included Iran and other parts of Asia that was founded in the sixth century BC (adjective: **Persian**)

Perspective: An artistic technique for creating the illusion of three dimensions and depth on a two-dimensional surface

Pietra dura: Literally means "hard stone" in Italian; the art of inlaying semiprecious, colored stones in another material

Pigment: A color derived from rocks, minerals, metals, plants, insects, or other materials that is mixed with a binder (e.g. oil, egg yolk, or gum arabic) to create paint

Pilgrimage: A religious voyage to a sacred site

Pilgrims: Religious travelers voyaging to a sacred site

Portrait: A painting, drawing, or photograph depicting the likeness of an actual person or group of people

Pounce: Charcoal or another fine powder that is dusted over a perforated drawing to transfer a design to another surface

Printing: The process of making a reproduction of an original image using a carved, etched, or engraved plate or block

Puja: Hindu worship in which offerings are made to deities

Quran: The holy book of Islam, believed to be the word of god as revealed to the prophet Muhammad

Radha: Female companion of the Hindu god Krishna in his youth, as described in the *Gita Govinda* and other devotional literature

Ragamala **(A Garland of Melodies):** A series of Indian musical modes and their accompanying paintings and verses

Raga: A key in which musical compositions are played in order to evoke certain emotions, themes, or seasons

Ragini: A subset of a raga intended to evoke certain emotions, themes, or seasons

Rajasthani school: Style of painting made for Rajput kings between the sixteenth and nineteenth centuries in the state of Rajasthan in northwest India. Some of the main centers of painting included Mewar, Bundi, and Bikaner.

Rajput: The rulers of the Rajasthan region of Northern India

Rama: The seventh incarnation of the Hindu god Vishnu and hero of the *Ramayana*

Ramadan: A month of fasting from sunrise to sunset observed by Muslims during the ninth month of the Muslim year

Ramayana: A great Hindu epic composed around 300 BC that relates the story of Rama and his wife Sita

Realism: An artistic style of representing things in an accurate or true way; lifelike (adjective: **realistic**)

Ritual: A religious ceremony or action that is usually done in a specific order

Sanskrit: An ancient language of India in which Hindu scriptures and ancient epic poems were written

Satyabhama: A Hindu goddess thought to be an incarnation of Devi; a wife of the god Krishna

Scale: The relative size of things in a work of art

School: A specific style of painting developed by artists working in a workshop or localized region

Shab-e-Barat: An annual Muslim holiday that celebrates forgiveness and salvation

Shahnama **(Book of Kings):** An epic poem that describes the story of the Persian Empire from the creation of the world until the seventh century AD

Shiva: One of the main gods in the Hindu religion

Shrine: A sacred site or structure associated with a divine presence, god, or a religious figure; can be within a religious building such as a temple or church, in one's home, or at a special natural location

Shuttle: A device used in weaving to carry the weft

Siddhartha: A name of the historical Buddha when he was a prince who lived in northern India during the fifth century BC

Sikhism: A religion founded in India in the fifteenth century that follows the teachings of ten gurus; followers believe in the equality of all humans and that one may connect with God through meditation, honesty, and service to humanity

Silk Road: An ancient network of trade routes crossing Europe and Asia that began roughly during the second century BC and lasted until the fifteenth century AD

Sita: The wife of Rama, the hero of the Hindu epic the *Ramayana*

South Indian school: Style of painting made in southern regions of India

Sufism: A branch of mystical Islam in which followers believe in surrendering to union with God; followers are known as Sufis

Sultan: The title of a Muslim king in India and other parts of South Asia

Sumi-e: A Japanese technique of brush painting

Symbol: An object that stands for something else other than itself, often an idea (adjective: **symbolic**; verb: **symbolize**)

Symmetry: The quality of having equal parts on either side of a line or point (adjective: **symmetrical**; adverb: **symmetrically**)

Textile: A cloth or woven fabric

Tutinama **(Tales of a Parrot):** A series of Sanskrit fables narrated by a parrot, re-written in several Persian versions up to the fourteenth century

Vedas: Ancient, sacred Hindu texts that began to be transmitted orally by priests three thousand years ago; describe myths of creation and the lives of the gods and goddesses

Vessel: A container made to hold a liquid, such as a bowl or cup

Vishnu: One of the main gods in the Hindu religion; the god of preservation and protection

Warp: The threads on a loom over and under which the weft is passed to create a weaving

Weft: The threads that are passed over and under the warp strings on a loom to create a weaving

Yogi: A spiritual person who practices yoga and meditation (feminine: **yogini**)

Zoroastrianism: An ancient religion founded by Zoroaster in Iran about 3500 years ago in which fire represents divine light or wisdom; followers also known as Parsis in India

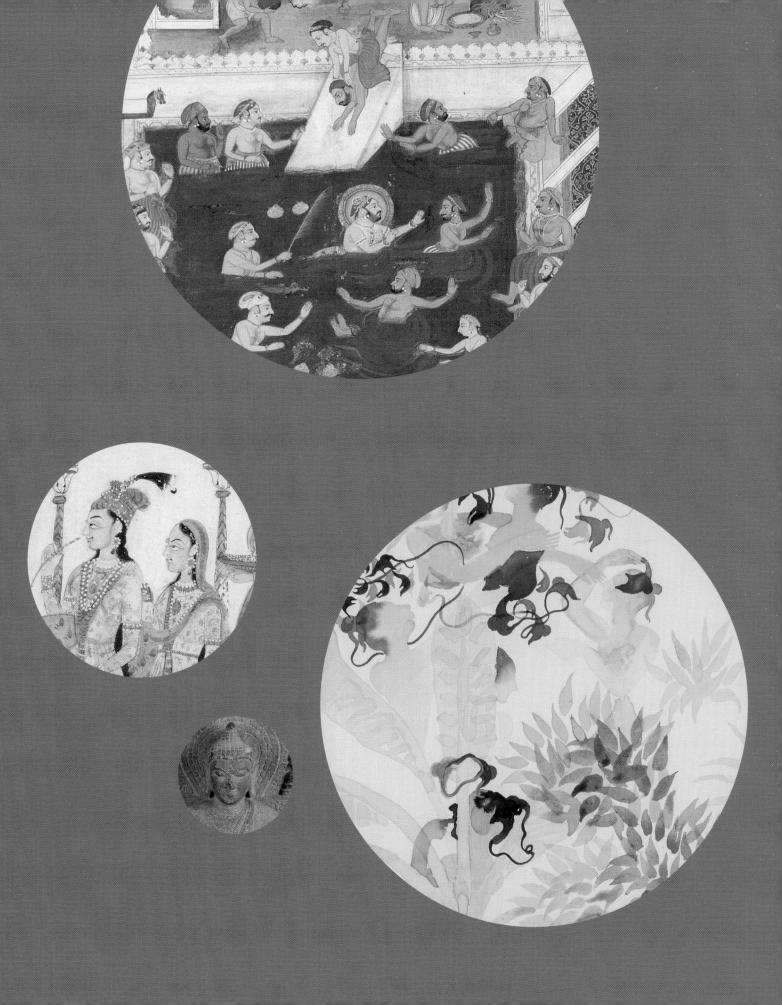

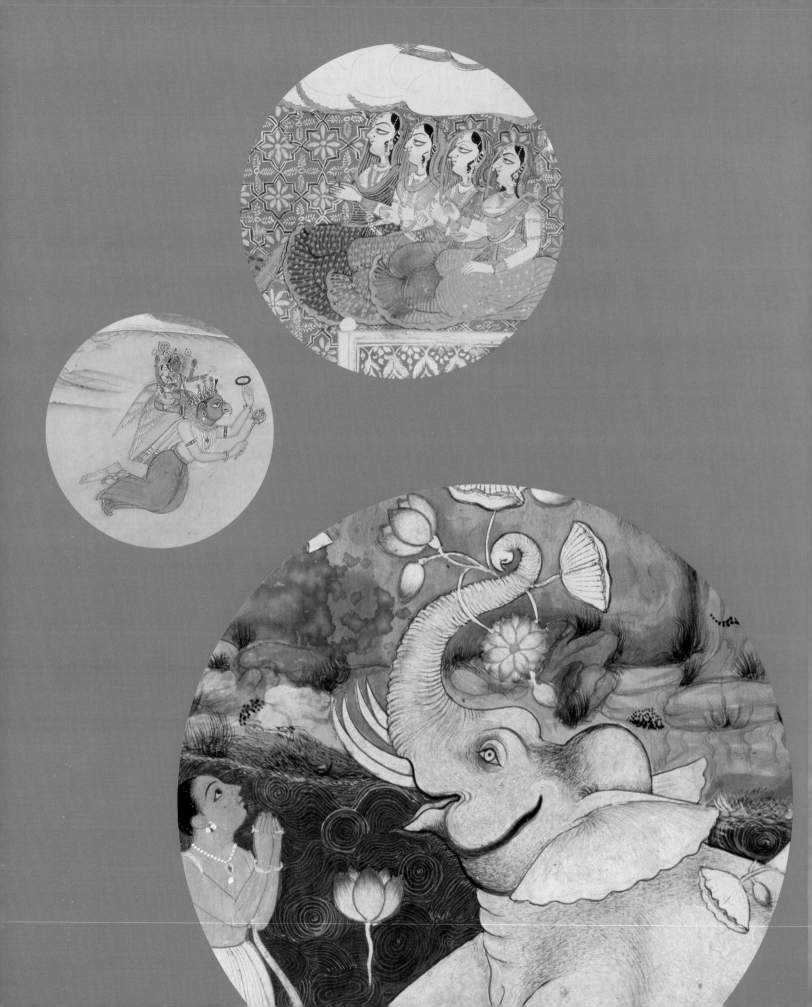

Further Reading

Aboff, Marcie. *India ABCs: A Book About the People and Places of India*. Country ABCs. North Mankato, MN: Picture Window Books, 2006.

Ali, Daud. *Ancient India: Discover the Rich Heritage of the Indus Valley and the Mughal Empire, with 15 Step-by-Step Projects and 340 Pictures*. Hands-On History! New York: Armadillo, 2014.

Aloian, Molly. *Cultural Traditions in India*. Cultural Traditions in My World. New York: Crabtree, 2012.

Apte, Sunita. *India*. True Books. New York: Children's Press, 2009.

Bingham, Jane. *Indian Art and Culture*. Chicago: Raintree, 2004.

Chatterjee, Manini, and Anita Roy. *India*. DK Eyewitness Books. New York: Dorling Kindersley, 2002.

Gyatso, Geshe Kelsang. *What Is Buddhism?: Buddhism for Children Level 3*. Glen Spey, NY: Tharpa Publications, 2013.

Holm, Kirsten C. *Everyday Life in Ancient India*. Jr. Graphic Ancient Civilizations. New York: PowerKids Press, 2012.

Hoobler, Dorothy and Thomas. *Where Is the Taj Mahal?* New York: Grosset and Dunlap, 2017.

Lassieur, Allison. *Ancient India*. The Ancient World. New York: Children's Press, 2012.

Patel, Sanjay. *The Little Book of Hindu Deities*. New York: Plume, 2006.

Ram-Prasad, Chakravarthi. *Exploring the Life, Myth, and Art of India*. Civilizations of the World. New York: Rosen, 2010.

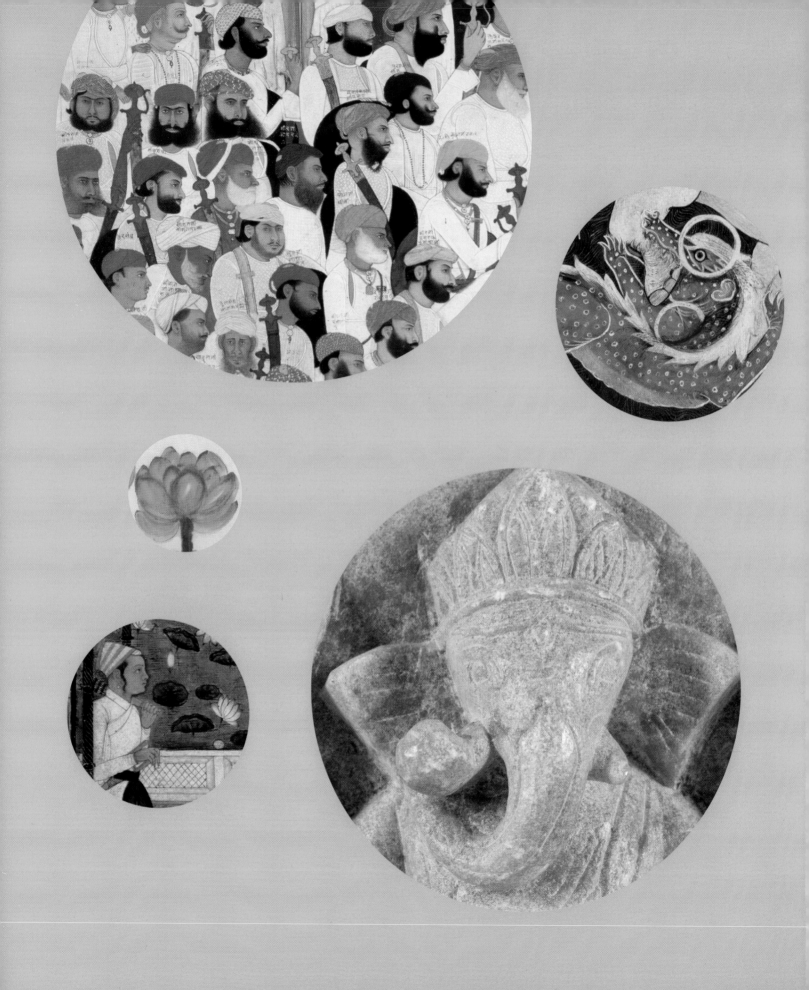

Credits

Anita Feldman, Series Editor

Editorial Committee
Diana Chou
Gwen Gómez
Sarah Hilliard
Cory Woodall

Illustrations
Jose Orara

Image Coordinator
James Gielow

About the Author

Lucy Eron Holland is a Museum Educator at The San Diego Museum of Art. Holland coauthored the first volume in this series *Myths, Angels, and Masquerades: Exploring European Art* in 2015 with Amy Gray. She received a master's degree in Art History from San Diego State University, where she has also been an instructor, and a bachelor's degree in Art History and Studio Art from the University of Virginia.

This publication would not have been possible without the generosity of the following support councils of The San Diego Museum of Art: the Arts Education Council, the Committee for the Arts of the Indian Subcontinent, and the Docent Council. The Museum is also grateful for funding provided by the Indo-American Arts Society, as well as the generosity of the following individuals: Behram and Rena Baxter; Jas Grewal and Suren Dutia; Ravinder and Cornelia Reddy; Ila Udani and Hasmukh Kamdar; and Deval Zaveri and Jimmy Tabb.

Library of Congress Control Number: 2017959798
ISBN 978-0-937108-56-7

Published by The San Diego Museum of Art
SDMArt.org

Distributed by ACC Distribution, New York
accdistribution.com

Produced by Lucia|Marquand, Seattle
luciamarquand.com

Photography provided by The San Diego Museum of Art

Edited by Sarah Hilliard
Designed by Ryan Polich
Layout by Meghann Ney
Typeset in Archer by Maggie Lee
Proofread by Barbara Bowen
Color management by iocolor, Seattle
Printed and bound in Malaysia by
TWP, Tien Wah Press

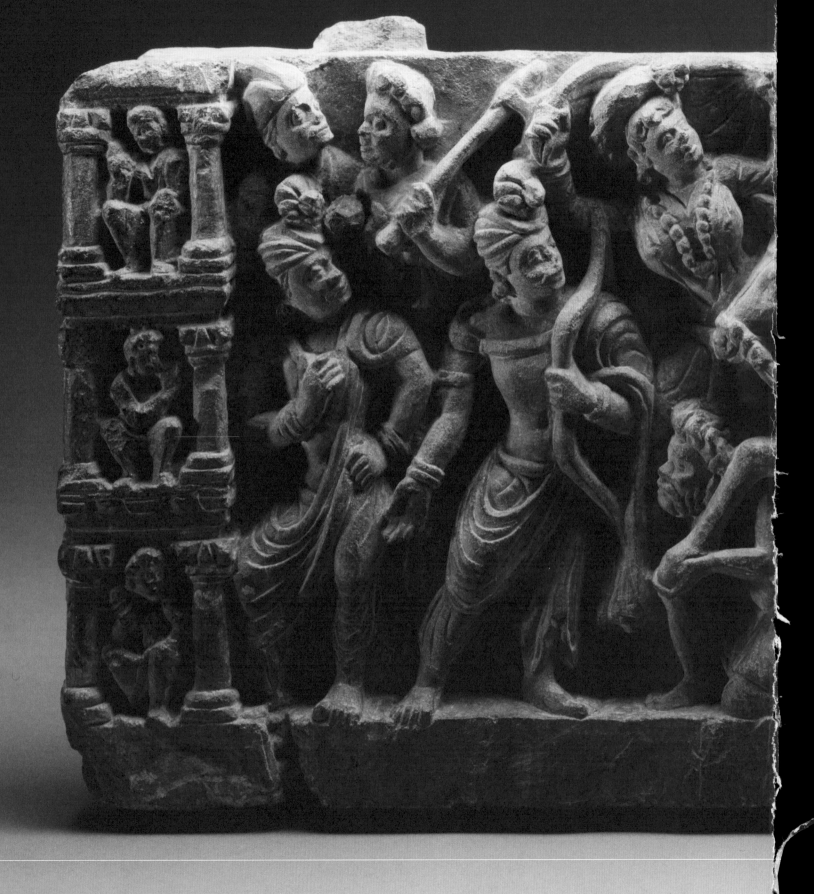